IMAGES
of America

BLUEFIELD

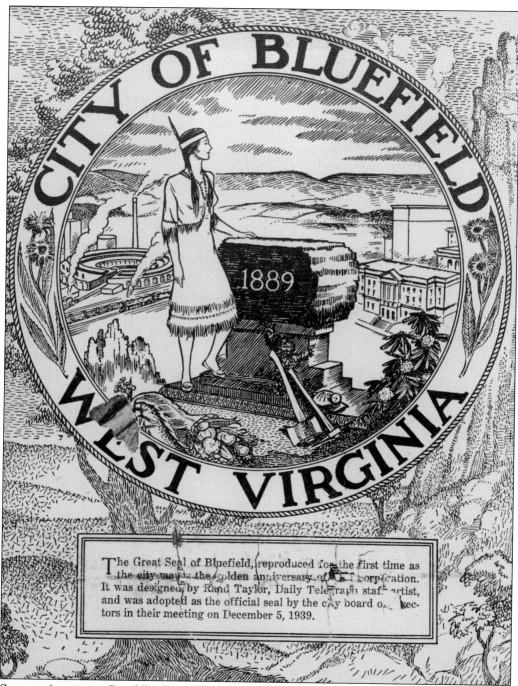

The Great Seal of Bluefield, reproduced for the first time as the city map at the golden anniversary of the corporation. It was designed by Rand Taylor, Daily Telegraph staff artist, and was adopted as the official seal by the city board of directors in their meeting on December 5, 1939.

SEAL OF APPROVAL. Rand Taylor, staff artist of the *Bluefield Daily Telegraph*, created the official Great Seal of the City of Bluefield in 1939. The seal was first published in a special edition of the newspaper. The Native-American maiden depicted on the seal is Princess Pocahontas. Early coalfield developers used the Pocahontas theme to promote the area; however, it is doubtful that Princess Pocahontas ever ventured this far west.

IMAGES
of America

BLUEFIELD

William R. "Bill" Archer

ARCADIA
PUBLISHING

Published by Arcadia Publishing
Charleston SC, Chicago IL, Portsmouth NH, San Francisco CA

Printed in the United States of America

Library of Congress Catalog Card Number: 00-104927

For all general information contact Arcadia Publishing at:
Telephone 843-853-2070
Fax 843-853-0044
E-mail sales@arcadiapublishing.com
For customer service and orders:
Toll-Free 1-888-313-2665

Visit us on the Internet at www.arcadiapublishing.com

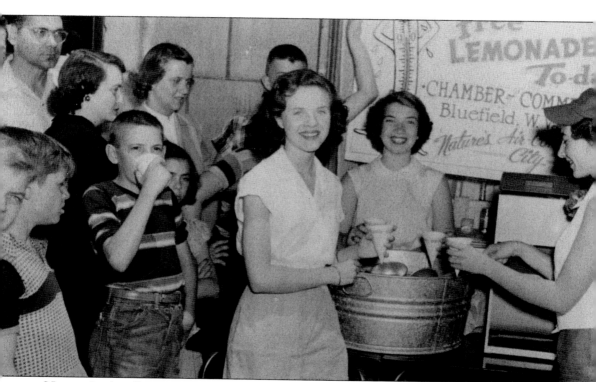

NATURE'S AIR-CONDITIONED CITY WELCOMES YOU. Lemonade Lassies Barbara Fleshman (center, foreground) and Carolyn McCue (right, in profile) are shown here serving free lemonade in the early 1950s. In 1939, Eddie Steele, manager of the Greater Bluefield Chamber of Commerce, created a publicity stunt whereby the chamber would distribute free lemonade on any day that the temperature exceeded 90 degrees Fahrenheit. However, it wasn't until 1941 that the temperature hit the mark and lemonade was served. (Photo courtesy of Nick Buzzo.)

CONTENTS

Acknowledgments 6

Introduction 7

1. Early Days 9

2. The Avenue 25

3. The City 35

4. Transportation 59

5. Chamber Business 69

6. Politics and War 77

7. Arts and Entertainment 95

ACKNOWLEDGMENTS

Several people helped me in compiling this pictorial history of Bluefield, and without their assistance, a work of this kind would not have been possible. First and foremost, I would like to acknowledge my wife, Evonda Archer, for her understanding, her patience, and her unwavering support—she's also my best critic and organizer.

I would also like to express my appreciation to Mel Grubb, whose photographic history of the city is exceptional. I thank Nick Buzzo for his incredible collection of photographs and his friendship; Cecil Surratt, for sharing his photos and memories; and Heber Stafford, for his incredible knowledge of the city.

I also express thanks to Thurman Scruggs for the use of his personal photos and to Jackie Oblinger for the use of her single picture of an interview she conducted with the late Jackie (then) Kennedy. I also thank Joseph Bundy for the use of several of his pictures from the city's African-American community. Also, Joe Davidson, of the original family of settlers in Bluefield, was helpful with pictures and support. Thanks to the Mahood family, Virginia Hebert, Bee Stringfellow, Eva Easley, and so many others who helped me understand Bluefield history. I also thank Steve Smith and Tom Colley, publisher and executive editor, respectively, of the *Bluefield Daily Telegraph* for standing in my corner when the fighting got rough.

Finally, I wish to thank my dear friend, H. Edward "Eddie" Steele, not only for the photos he contributed to this project, but also for all the days and hours we have spent just talking about Bluefield. Eddie, this one's for you.

INTRODUCTION

Bluefield is just as much a state of mind as it is a city. Built on the spine of a natural gravity "hump" that divides the Norfolk Southern Railway's ever-sloping mainline track from the Atlantic Ocean to the east and the Ohio River in the west, Bluefield has eternally played a pivotal role in American railroading.

Bluefield's role in America's so-called "Industrial Revolution" has been perpetually swept up in a constantly changing dynamic. The city's unrelenting power and pervasive compassion combine to forge a place that is unique in the world.

Bluefielders know who they are. The city's native sons and daughters have walked among the giants in the far-flung fields of music, mathematics, business, entertainment, communications, technology, the military, and beyond. Consider that Maceo Pinkard, composer of "Sweet Georgia Brown," a number one *Billboard* hit in the summer of 1925, was born on Raleigh Street in Bluefield on June 27, 1897.

John S. Knight, founder of the Knight-Ridder News Agency, was born on Raleigh Street in Bluefield on October 26, 1894. Ruth Alice Bowman, mother of General Norman Schwarzkopf, was raised in a home at 501 Highland Avenue in Bluefield.

The 1994 Nobel Laureate in economics, Dr. John Forbes Nash Jr., was born in the Bluefield Sanitarium on June 13, 1928, and on August 21, 1921, Clarence Ridley, revered as the father of the city-manager form of government, accepted his first and only job as a city manager of the City of Bluefield.

Frank Sinatra appeared in Bluefield with the Tommy Dorsey Orchestra near the start of his exceptional career, and famed country music star Hank Williams Sr. may have drawn his last breath on his final journey that paused briefly in Bluefield on December 31, 1952.

Legendary jazz man Louis Jordan made a hit with a song called "Salt Pork, West Virginia," which chronicles a run-in he had in 1942 with Bluefield's justice of the peace "Squire" W.W. McNeal, and Edward "Duke" Ellington, perhaps the greatest jazz/swing composer/performer of the 20th century, joined the Alpha Phi Alpha Fraternity on December 12, 1966, in Bluefield at the request of his lifelong friend and well-known Bluefield dentist, Dr. Ernie Martin.

Thanks to the enterprising and innovative spirit of its citizens, Bluefield became a leader in the field of communications. David E. Johnston, whose book titled *A History of the Middle New River Settlements* (1906) still stands as the definitive history of the region's early settlers, was the first president of the Bluefield Telephone Company, which was founded on June 3, 1893, and was the earliest system in the General Telephone Company system.

Perhaps the greatest communications story in the city can be traced from the annals of the Shott family. In 1895, Stanton, Virginia native Hugh Ike Shott Sr. decided to make Bluefield his hometown. He invested in a newspaper called the *Bluefield Telegraph*, and by the start of 1896, he had acquired control of the newspaper. On January 16, 1896, he launched the *Bluefield Daily Telegraph*, a seven-day-per-week paper that continues to publish daily through the coalfields.

The *Telegraph* remains a morning paper, but for almost 50 years, the Shotts operated an afternoon paper as well, the *Sunset News Observer*, which ended its run in the early 1970s. The family launched FM radio station WHAJ (now popularly called J-104) in 1922, and on June 24, 1929, the family started broadcasting WHIS radio. In 1955, the Shotts launched television station WHIS-TV, which remains on the air although its call letters are now WVVA-TV, and it is now owned by the Oakley family of Quincy, Illinois.

Bluefield has been an innovator in terms of education. Bluefield State College was established on February 1, 1895, as an institution of higher learning for African-American students. Since integration, it serves all races and has grown as a commuter college.

The city's public schools have always provided an exceptional education to students. During segregation, Beaver High School served white students and Genoa, and later Park Central High School, served black students. Those institutions were combined in the late 1960s. Bluefield's public school system is the only system in the state that can boast of having educated a Nobel Laureate: Dr. John Forbes Nash graduated from Beaver High in 1945.

Indeed, the city's spiritual life is well served. Almost every Protestant denomination is represented in the city, as well as the Sacred Heart Catholic Church and the Jewish congregation of Ahavath Sholom. Early in the year 2000, the unique spires of a Russian Orthodox church rose in the city and a new Muslim mosque was built in 1999 just a few miles east of the city limits.

Like many American cities, Bluefield has suffered from changes that have hit traditional downtown areas nationwide. The rise of personal automobile ownership in the 1950s foretold the passing of the large-scale public-transportation era for cities similar to Bluefield. The mighty Norfolk & Western Railway ended passenger service, although the Bluefield yard remains the busiest in the (now) Norfolk Southern Railway system, where coal is still king.

Personal vehicles and better roads made it possible for people to live further and further away from their work. That phenomenon essentially ended the southern West Virginia coal camps. When combined with the increased mechanization in coal mining and the conversion from steam locomotion to diesel power in the railroads, the city experienced a population loss that few communities could survive. Bluefield had a population of more than 25,000 in 1950 (52,000 if including the surrounding communities). In 1990, the city's population fell to 12,600, even after some limited annexation. But thanks to progressive thinking on the part of visionary leaders, Bluefield is well positioned to function as a 21st-century city devoid of smokestacks and noon whistles, but strong on fresh, clean, cool mountain air, and a history of diversity.

In 1939, Bluefield's most-beloved newspaperman, H. Edward "Eddie" Steele, coined the slogan, "Nature's Air-Conditioned City." Indeed, Bluefield is "air-conditioned," but it is also forged from the will of its strong and diverse nature, and tempered by the undying spirit of her stalwart sons and daughters. This is their story.

One

EARLY DAYS

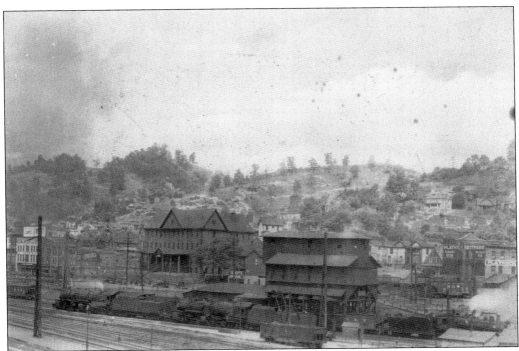

A TOWN BUILT BY RAIL. After the completion of the Bluefield yard, the Norfolk & Western Railway built a large YMCA building, shown in this photograph (*c.* 1888) on the city's northside, to provide housing for employees. The "Y" was the dominating northside structure for the first two decades of the city's history. (Photo courtesy of Nick Buzzo.)

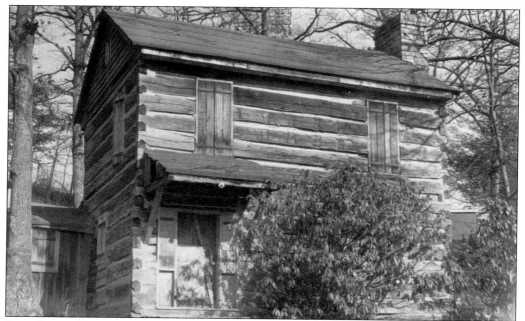

LOG CABIN COUNTRY. People concerned with preserving the city's historical roots saved the log structure shown here and restored it on a lot in Bluefield's City Park. The cabin was erected by the family of John Goolman Davidson, a native of Dublin, Ireland, and cooper by trade who received a grant in 1767 from King George III of England for the land. (Photo courtesy of Nick Buzzo.)

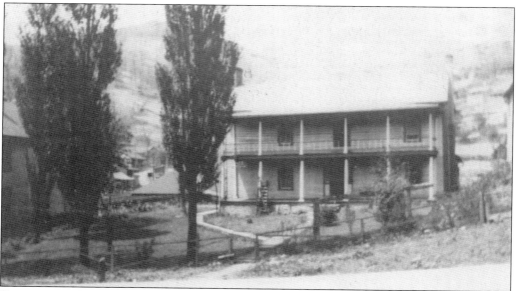

FARM IN THE VALLEY. The Davidson home is visible on the city's northside prior to being restored in City Park. John Goolman Davidson and his family, along with Richard Bailey and his family, settled the land that is now Bluefield in 1780. The old Davidson-Bailey Fort was located near the present Westgate Shopping Center in Bluefield, Virginia. (Photo courtesy of Nick Buzzo.)

FIRST LADY OF BLUEFIELD. Elizabeth "Lizzie" Miller Davidson, shown here flanked by daughters Julia (left) and Jean, is credited with having said, "Oh, what lovely blue fields," remarking to Bluefield's first post mistress, Hattie Hannah, as they observed the blue Mountain Chicory blooming in the area where the city would be. At the time, the Norfolk & Western Railway referred to the area as "Higginbotham's Summit," but Mrs. Hannah submitted the name "Bluefields" to the U.S. Post Office. The "s" on the end was dropped prior to the city's incorporation on November 20, 1889. (Photo courtesy of Joe Davidson.)

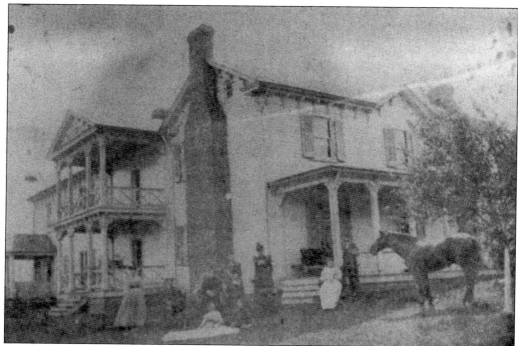

THE HIGGINBOTHAM HOMESTEAD. While the Davidson family's home was located in the city's northside, the home of J.B. Higginbotham, shown above, was located on land that would become headquarters to the Norfolk Southern Pocahontas Division. The city's first post office was located here on January 11, 1886. (Photo courtesy of Garnett Webb.)

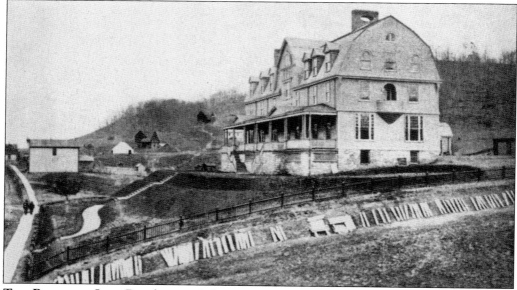

THE BLUEFIELD INN. Developers of the Norfolk & Western (N&W) Railway built "inns" similar to the one shown here along the N&W mainline to provide lodging, as well as space, for railroad offices. This building was removed to make way for the modern Norfolk Southern Pocahontas Division headquarters. (Photo courtesy of Nick Buzzo.)

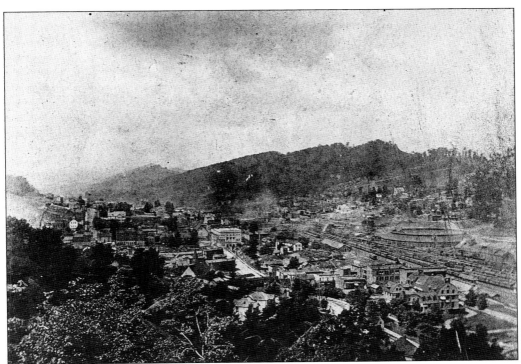

START OF THE 20TH CENTURY. This 1902 photo from the Norfolk Southern Archives shows Bluefield from a vantage point in the city's east end. Note the railroad yard filled with freight cars, the roundhouse, and the relatively new Elks Opera House in the center of town. (Photo courtesy of Norfolk Southern [NS].)

BLUEFIELD FROM THE WEST. This 1890 photograph shows the very early buildings of Bluefield a few months after it was incorporated as a city in 1889. Norfolk & Western laid a single track through in 1882 where the city now stands. Just eight years later, 5,000 people called Bluefield home. The church noted in the picture is Bland Street Methodist, and the knoll in the center is where the Bailey Building now stands. (Photo courtesy of Grubb Photo Service.)

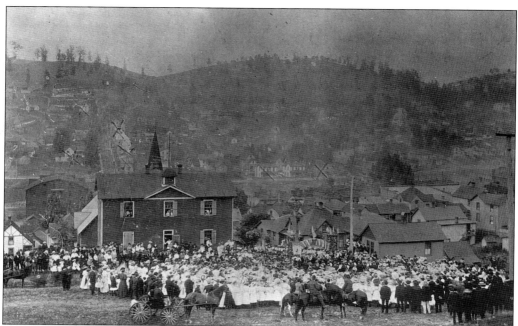

GOOD SCHOOLS. A large crowd turned out for the groundbreaking ceremony at the first Bluefield High School in 1912, when Grace United Methodist remodeled and changed its spire. The frame structure just to the north of the crowd was used as a school annex building even after the high school was erected at Thomas and Third Streets. (Photo courtesy of Nick Buzzo.)

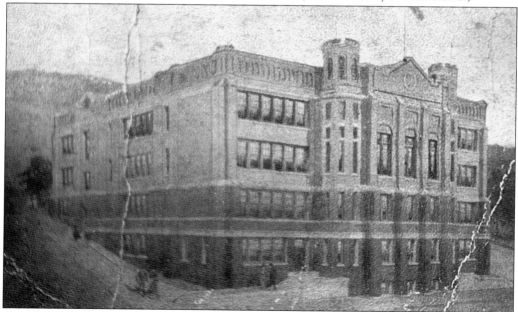

OLD BEAVER HIGH. Because it was located in the Beaver Pond District, the old Bluefield High School was unofficially dubbed "Beaver" through its early years. The original brick structure shown here in this 1909 postcard was destroyed by fire in 1925 and was replaced by a brick structure that still stands. (Photo courtesy of Nick Buzzo.)

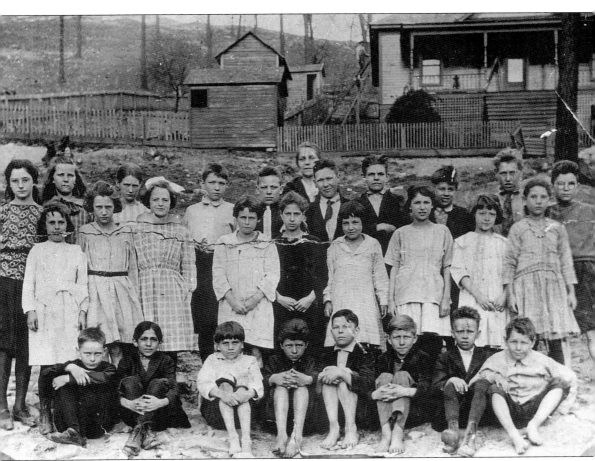

THE OLD STINSON SCHOOL. The students shown here attended the old Stinson School on the city's northside. Like many coalfield communities, Bluefield's population benefitted from great diversity. Of course, the schools were segregated due to the prevailing Jim Crow laws in the early years of the 20th century, but young people of all backgrounds learned to work together. In the very early days, Bluefield's wealthiest families built residences on the northside, but through the years, the wealthy residential section moved in the direction of southern Bluefield. (Photo courtesy of Nick Buzzo.)

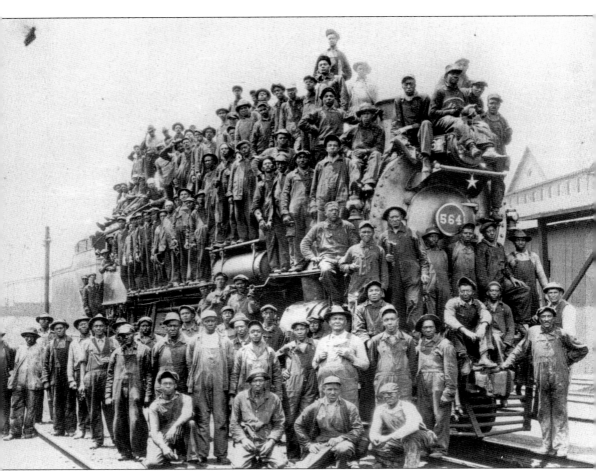

WORKING ON THE RAILROAD. The Norfolk & Western Railway, although based in Richmond, Virginia, was funded by a group of Philadelphia investors, headed by E.W. Clark & Company. The existence of coal was known as early as 1750, following the first comprehensive two-year survey of the area by Dr. Thomas Walker. The commercial exploitation of the region's mineral resources started in 1882, and at the time the most plentiful labor pool available consisted of African Americans. According to Julia Bundy, the man standing in the front of this picture with his thumbs hooked in his coveralls is her grandfather, Grant Ulysses Watkins. The old Railroad YMCA is in the background. As many as 300 men per shift worked in the N&W Bluefield yard. (Photo courtesy of Joseph Bundy.)

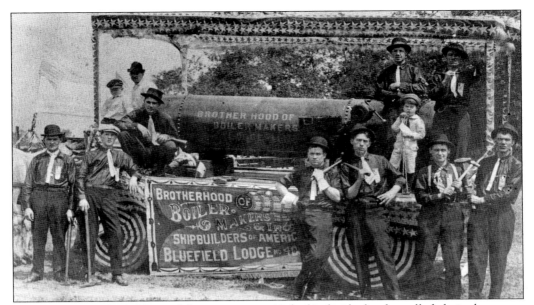

WORK ETHICS. Bluefield's workforce was comprised of individuals who rolled their sleeves up and didn't mind putting in a full day's work. None of the people shown in this picture are identified, but they are typical of the workers who pitched in to create a civilization out of an untamed wilderness. (Photo courtesy of Grubb Photo Service.)

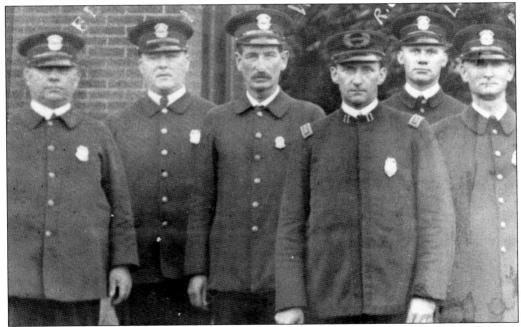

BLUEFIELD'S FINEST. The city police department got off to an inauspicious start. The first policeman, W.S. Jonnson, was appointed by the city on March 19, 1890, and was murdered a month later on April 12, 1890. Officers shown here include, from left to right, the following: unidentified, Bob Lilly, Wirt Bailey, unidentified, ? Lilly, and unidentified. (Photo courtesy of Nick Buzzo.)

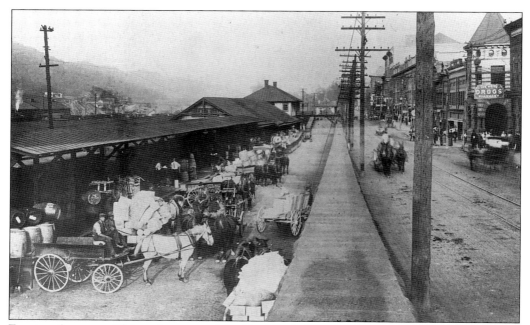

FREIGHT STATION. This early scene of the Norfolk & Western freight station (*c.* 1912) along Princeton Avenue shows how important the city became as a hub for the redistribution business. The photo was taken at a time when trains, horses, and streetcars dominated the modes of transportation. (Photo courtesy of Grubb Photo Service.)

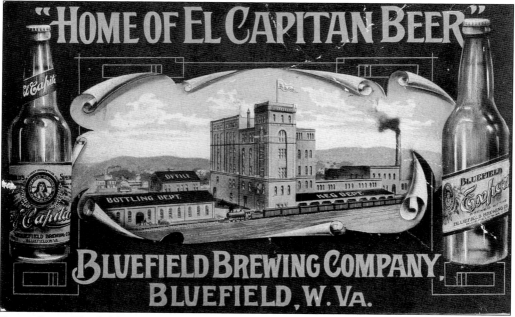

SUDS CITY. Bluefield Brewing Company, located on Bluefield Avenue, distributed spirits throughout the coalfields. The labels produced in the brewery included "El Capitan" and "Export." It later became the Southern Maid Ice Cream Company, a grocery store, and is presently the location of the *Bluefield Daily Telegraph*. (Photo courtesy of Grubb Photo Service.)

18

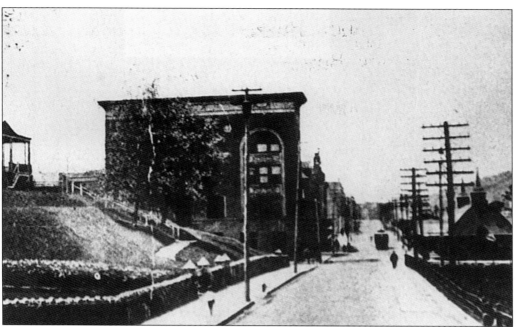

LAND HO. The Pocahontas Land Co., a wholly-owned subsidiary of Norfolk Southern Corporation (NSC), set up shop on Princeton Avenue in 1900. Pocahontas Land is the mineral resources management company for NSC. (Photo courtesy of Nick Buzzo.)

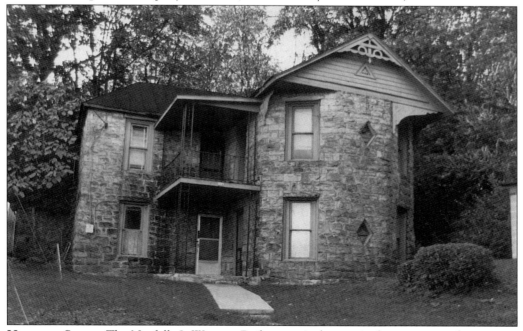

HOUSE OF STONE. The Norfolk & Western Railway actively recruited stonemasons from the Italian Alps to build the infrastructure needed to create a foothold in the mountains of southern West Virginia. This home on Bedford Street was built by one of Bluefield's stonework contractors. Several stonemasons lived on Bedford Street. (Photo by the author.)

ROLL OUT THE BARRELL. Delivery men are shown here getting loaded at the Bluefield Brewery loading dock. Bluefielders have a great tradition of getting involved in their work. (Photo courtesy of Grubb Photo Service.)

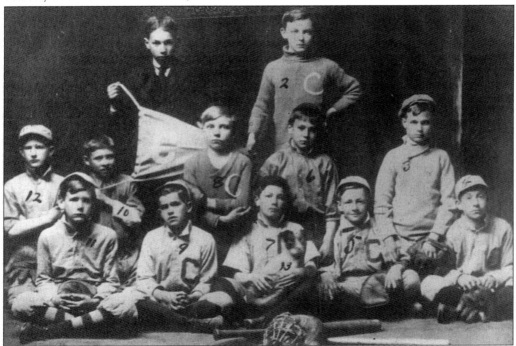

THE OLD BALL GAME. Youngsters in Bluefield paused for a team photo before heading to the field. Shown, from left to right, are the following: (front row) William Garvin, (future Army general) Hershall Middleswarts, (local contractor) George McCullough, (mascot) Robert Hawks, and (son of Bluefield Sanitarium founder) Frank Fox; (second row) Arthur Parker, (WHIS-TV founder) Jim Shott, Clarence Drinkland, (later head of the Coal Association) Lewis Poff, and John Jolliffe; (standing) Guy Rangely and Paul Thomas. (Photo courtesy of Nick Buzzo.)

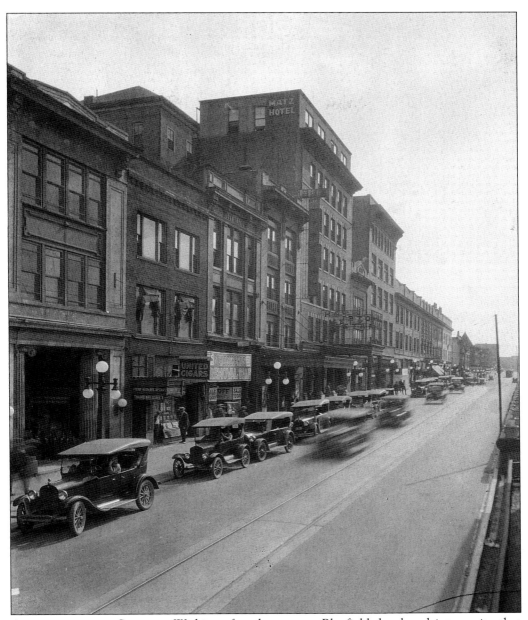

ACROSS FROM THE STATION. Within a few short years, Bluefield developed into a city that begged to be viewed from the railroad station. The only building that remains of this busy section is the Hotel Matz. A pair of theaters, the Rialto and Colonial, booked some of biggest vaudeville acts of the day, and famed cowboy star Roy Rogers and his horse Trigger appeared on the Colonial stage. (Photo courtesy of Nick Buzzo.)

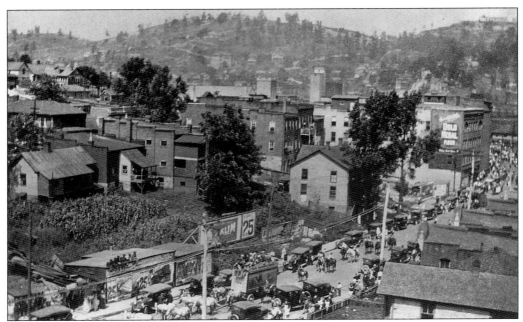

LOVE A PARADE. When the circus made its annual visit to Bluefield, the parade through town was a big event as evidenced by this early view of Federal Street. The tall structure in the background is the Bluefield Mill, a gristmill on the city's northside that was operated by W.S. Cole. Bluefield had a strong tradition of holding parades. (Photo courtesy of Grubb Photo Service.)

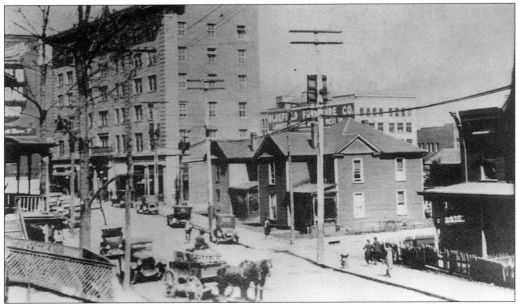

HORSE AND BUGGY DAYS. This scene shows Federal Street before the coming of the West Virginian Hotel. The largest structure in the photograph is the Law and Commerce Building. The photograph was taken from the present location of First Century Bank. (Photo courtesy of Nick Buzzo.)

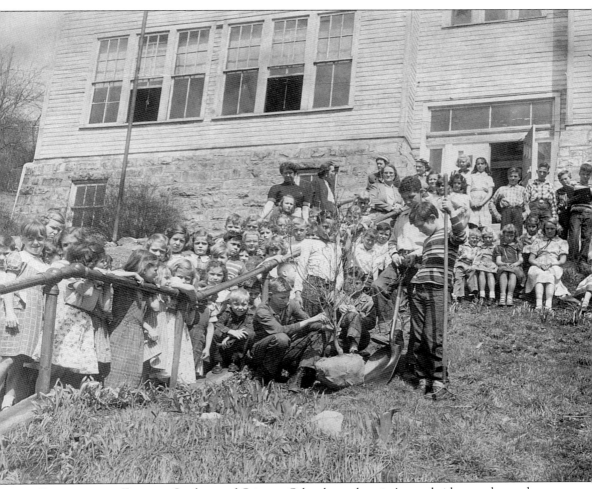

SEEDS OF THE FUTURE. Students of Stinson School on the city's northside are shown here participating in some kind of a tree-planting ceremony at the old school. Although Stinson School is long gone, the tradition of holding tree-planting ceremonies at Bluefield schools continues today. Timber, as well as coal, has always played a significant role in the city's dynamic history. Annie D. Woolwine was principal. (Photo courtesy of Nick Buzzo.)

COMPANY POLICE. William G. Baldwin established the West Virginia Coal and Iron Police in Bluefield in 1895 and then hired his services out as private law enforcement to the Norfolk & Western Railway and later to the various coal mine operators. (Photo courtesy of author.)

THE AGENCY. Thomas L. Felts joined William Baldwin in 1897 to form the famous Baldwin-Felts Detective Agency. Called "Felts Thugs" by coal miners, the operatives gained a reputation for hard-nosed tactics. Two of T.L. Felts's brothers, Albert and Lee, were killed by striking coal miners on May 19, 1920, in Matewan. (Photo courtesy of author.)

Two

THE AVENUE

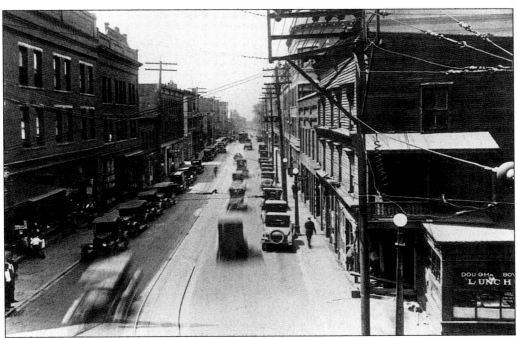

THE AVENUE. Bluefield grew like most cities to have sections that carried a definite flavor with them. Bluefield Avenue was crowded, busy, and exasperating at times, but it was also where the business of the coalfields was conducted. The city's great supply houses developed on the avenue, and because of constant pickups and deliveries, hour-long delays were not uncommon. (Photo courtesy of Nick Buzzo.)

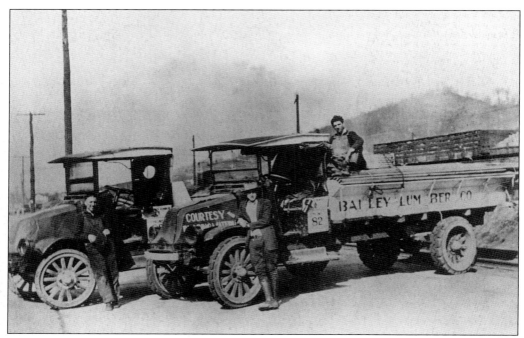

TRUCKERS. Lumber and building supplies were in great demand throughout the coalfields, and companies like Bailey Lumber, headquartered on Bluefield Avenue, grew to meet that need. Bailey Lumber had several locations throughout the coalfields. The business was founded by Captain E. "Bud" Bailey in 1912. (Photo courtesy of Grubb Photo Service.)

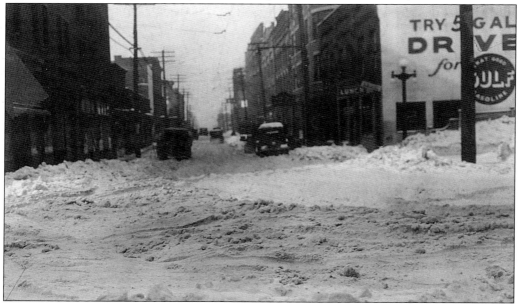

SNOW-COVERED AVENUE. Although Bluefield Avenue (at Mercer Street looking west) was difficult to traverse in good weather, it was next to impossible during periods of heavy snowstorms, as evidenced in this February 27, 1934 picture. The Dough Boy Lunch managed to stay open—in fact, it never closed. (Photo courtesy of Mary Theodorou.)

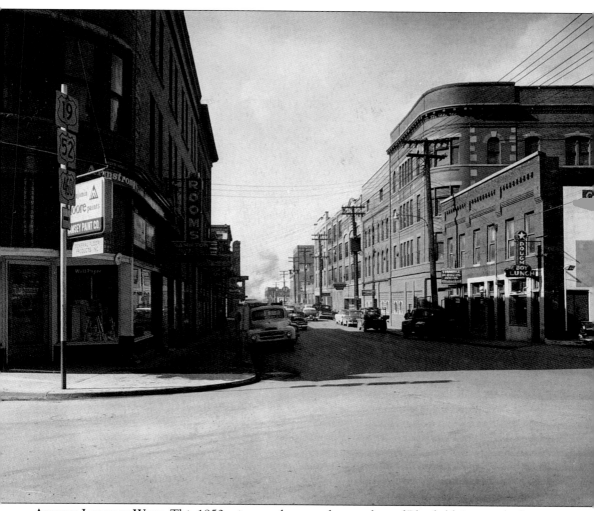

AVENUE LOOKING WEST. This 1950s vintage photograph was taken of Bluefield Avenue looking in the direction of Bluefield, Virginia. The building on the right with the rounded edge served as headquarters to Bluefield Supply, possibly the most prolific of the city's great supply houses. This is a similar view to what Charles Carr, driver for Hank Williams Sr., must have seen when he stopped at the Dough Boy and hired Bluefielder Don Surface to help him drive to Canton, Ohio, on the night of December 31, 1952. A few hours later when they reached Oak Hill, West Virginia, Carr and Surface discovered that Williams was dead. (Photo courtesy of Nick Buzzo.)

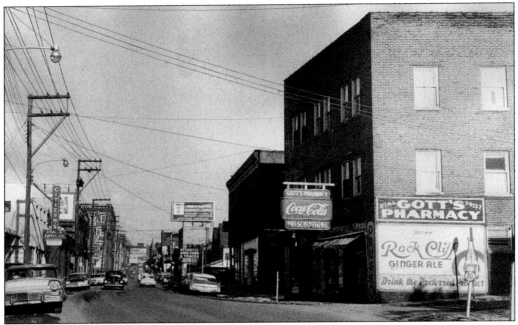

Avenue Looking East. Along with the big supply houses, the Avenue (at Chestnut Street) was home to a thriving business community in the late 1950s, as shown in this picture looking east in the direction of Princeton, West Virginia. Citizens Building Supply is one of the few remaining businesses of those pictured above. (Photo courtesy of Nick Buzzo.)

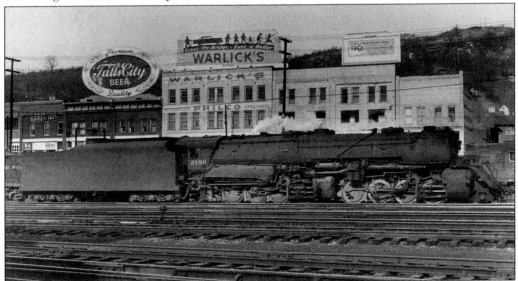

Avenue Looking to the North. Warlick's Furniture asked its customers to "Cross the Bridge & Save a Dollar," in reference to the old Mercer Street Bridge, which has been renamed the Martin Luther King Jr. Memorial Bridge in recent years. When Warlick's moved downtown, they started advertising, "You don't have to cross the bridge to save a dollar." There are five vehicular bridges and one foot bridge that eliminate the need for grade crossings in the city. (Photo courtesy of Grubb Photo Service.)

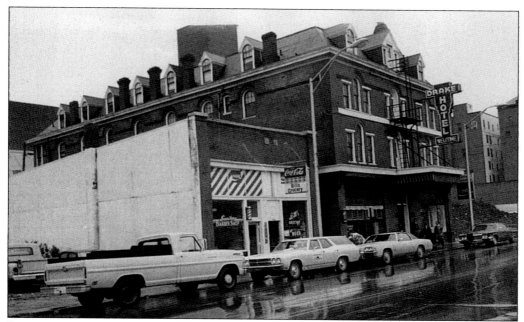

PRINCETON AVENUE. At Stewart Street, the thoroughfare divides between Bluefield Avenue to the west and Princeton Avenue to the east. The Drake Hotel was a "hot spot" on Princeton Avenue with a variety of activities going on constantly. (Photo courtesy of Nick Buzzo.)

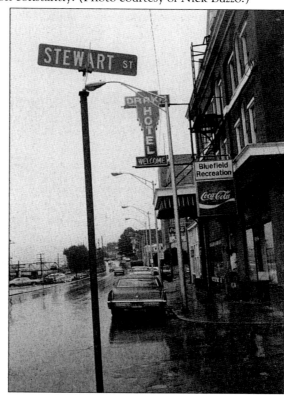

THE AVENUE AT STEWART. There was always a great deal of action taking place at Bluefield Recreation, an early-day "sports bar," and the Drake Hotel. (Photo courtesy of Nick Buzzo.)

LOOKING UP STEWART STREET. The area shown here is near the section of town that was called "Vito's Alley." The work to the right in this picture was part of the construction of the Princeton Avenue Parking Garage. (Photo courtesy of Nick Buzzo.)

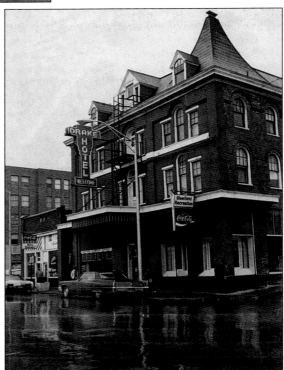

THE DRAKE. This is yet another view of the Drake Hotel. For many people who arrived in Bluefield by rail, the Drake was one of the first sights of the city. (Photo courtesy of Nick Buzzo.)

WEST END BLUEFIELD AVENUE. This section of Bluefield Avenue, as seen from the Easley Bridge, shows how busy the Avenue could get. This picture was taken during one of the first Southern Appalachian Industrial Exhibits, forerunner to the biennial Bluefield Coal Shows of the present day. Note the Feuchtenberger Bakery and Wade Field on the left, and National Electric Coil on the right. (Photo courtesy of Grubb Photo Service.)

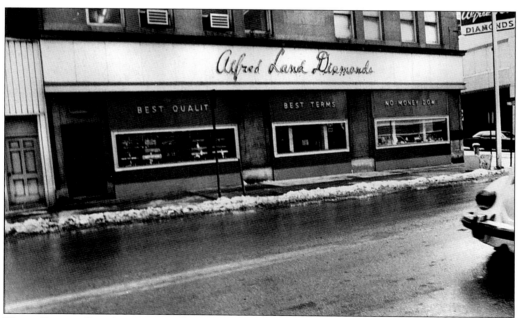

HEAD STAND. Popular city merchant Alfred Land often boasted in his TV commercials that he would "stand on his head to please you." Al Land Diamonds was located on the corner of Princeton Avenue and Federal Street at the former location of First National Bank. The above site was where the bank's "snorkle" or first drive-up teller was located. (Photo courtesy of Nick Buzzo.)

THE AVENUE BEAT. For years, veteran Bluefield City Police officer Paul Oliver walked the Bluefield Avenue "beat." One of his many stops along the way was at the Dough Boy, where owner Gus Theodorou (left) and his partner, Sam Nikas, kept the business open on a 24-7 basis, year-round. Theodorou was a Greek immigrant who opened the restaurant to cater to soldiers returning home from World War I. Among other things, the Dough Boy served hot dogs that were unforgettable. (Photo courtesy of Hazel Shultz.)

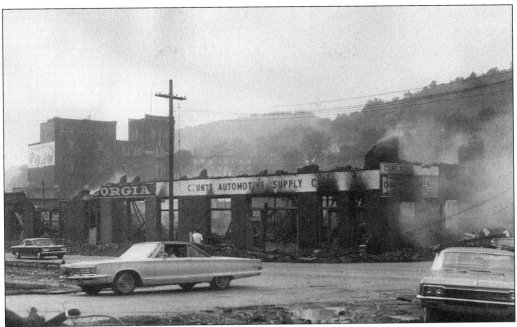

DESTROYED BY FIRE. The old Georgia Lumber Store and Counts Automotive were mainstays until the building that housed the businesses was destroyed by fire in the 1960s. (Photo courtesy of Nick Buzzo.)

BACK ON BLUEFIELD AVENUE. The old Martin Building was a rooming house constructed by former Bluefield mayor Dr. J.E. Martin, who served in 1896. Dr. Martin was the grandfather of 1994 Nobel Laureate, Dr. John Forbes Nash Jr., whose son, Dr. John Martin Nash, carries the former mayor's name. (Photo courtesy of H. Edward "Eddie" Steele.)

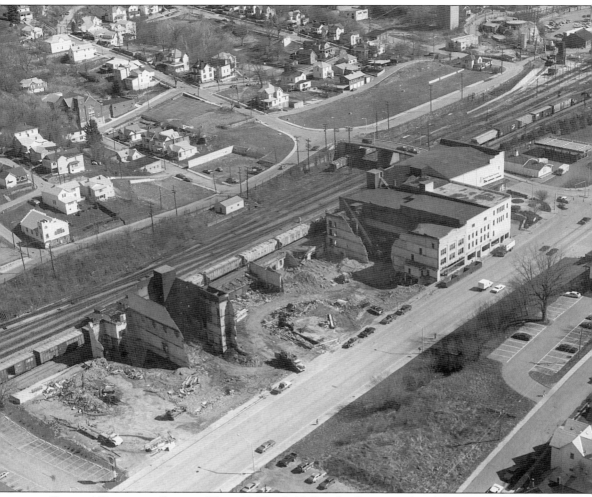

Razing Bluefield Supply. The old Bluefield Supply Company headquarters is shown here being demolished in April 1988, to make way for a new distribution warehouse, now owned by Bluefield-based Paper Supply Company. Most of the Bluefield Avenue buildings were demolished as part of a mid-1960s urban renewal program that broadened the Avenue to five lanes and greatly improved accessibility to the downtown area. Still, many oldtimers remember with great fondness the days when the Avenue was the heart of Bluefield's distribution empire. Some of the great Avenue businesses were Superior Sterling; Bluefield Grocery; Bluefield Distributing; Huff, Andrew and Thomas; Sublet Feed & Supply; and others. (Photo courtesy of Grubb Photo Service.)

Three

THE CITY

HEADING UP BLAND STREET. The old 1895-vintage Pedigo Building on the corner of Princeton Avenue and Bland Street was initially constructed as the People's Bank of Bluefield but soon was sold to the First National Bank. The building has served many purposes throughout the years. After 1918, Pedigo's Store and White's Pharmacy were located there. Three different types of cut sandstone were used to build the structure. (Photo courtesy of Grubb Photo Service.)

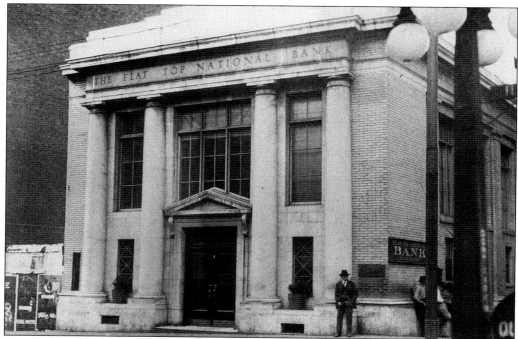

BANK ON IT. The old Flat Top National Bank was located on the corner of Federal and Raleigh Streets, in much the same location as its predecessor, Bluefield's First Community Bank. The Pocahontas Coalfields were previously known as the Flat Top Coalfields before the Pocahontas Operators Association so successfully marketed the name. (Photo courtesy of Grubb Photo Service.)

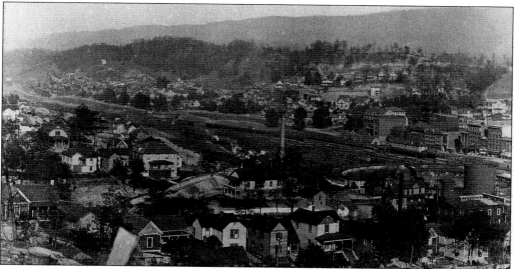

LOOKING TO THE SOUTHEAST. This northside view of Bluefield shows the growth of the city's east end. The old roundhouse is to the right of the picture and the residential area was confined rather close to the Norfolk & Western mainline. The smokestack was owned by the railroad and produced heat for N&W buildings through underground pipes that connected to the railroad offices. (Photo courtesy of Grubb Photo Service.)

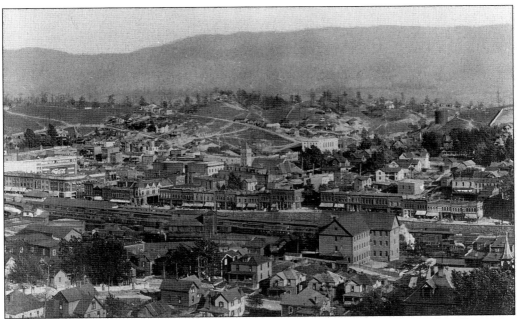

HEART OF THE CITY. In this old photo, taken from the northside, the storefronts along Princeton Avenue are apparent as well as the Pedigo Building. The light-colored structure near the center of the photograph is the Elizabeth Kee Federal Building. The coal wharf was where N&W employees cleaned locomotive fireboxes. (Photo courtesy of Grubb Photo Service.)

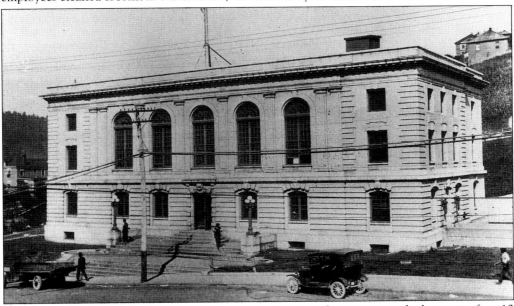

ELIZABETH KEE FEDERAL BUILDING. Because of the city's dramatic growth during its first 12 years, a congressional seat was established in Bluefield in 1901. It took 10 years before the actual physical court was built. The Kee family—John; his wife, Elizabeth; and later their son, Jim, all Democrats—held the seat until it was absorbed into the Fourth District. (Photo courtesy of Grubb Photo Service.)

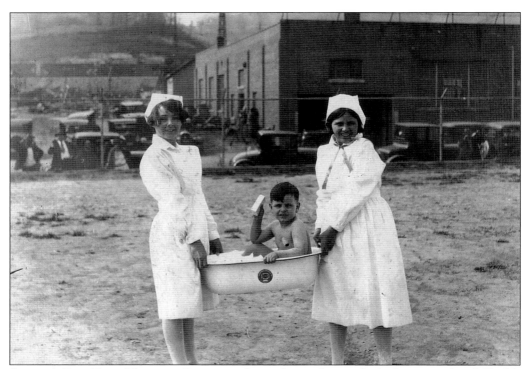

SCRUB-A-DUB-DUB. Thurman Scruggs is shown here taking a bath during a "Good Health Day" activity at Wade School (*c.* 1930). At the time, the Old Wade Field was the city's most popular gridiron. (Photo courtesy of Thurman Scruggs.)

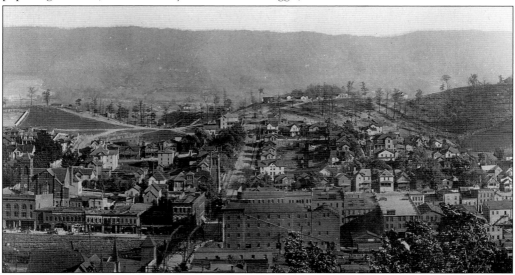

LOOKING UP MERCER STREET. At the time this photo was taken, the downtown area wasn't fully developed and as a result, a great deal of activity was taking place at the junction of North and South Mercer Streets and Princeton and Bluefield Avenues. Note the old Mercer Street Bridge shown above. Bluefield Hardware was then F.W. Udy & Sons. (Photo courtesy of Nick Buzzo.)

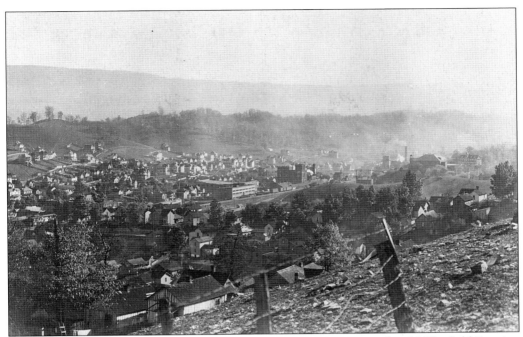

THE FAR WEST END. The tall building in the center of this picture is the old Bluefield Brewing building. The city's growth was primarily confined to the area near the railroad tracks. (Photo courtesy of Grubb Photo Service.)

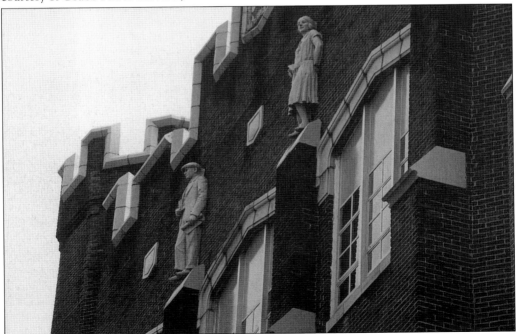

BEAVER HIGH IN DETAIL. The photo above shows a detailed look at the statue of a young man and young woman near the top of the castle-like Beaver High School building. (Photo courtesy of author.)

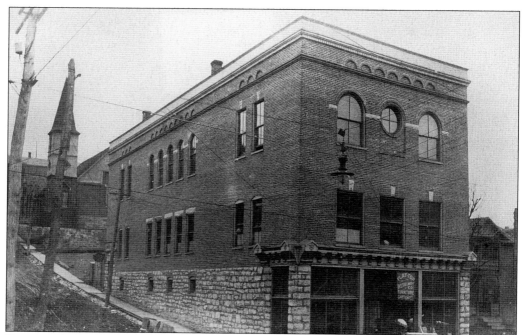

BLUEFIELD'S BUSINESS DISTRICT. With the growth of population, retail businesses like the Flat Top Furniture Company, shown above, flourished. The building, located on the corner of Bluefield Avenue and Thomas Street, also served as Red Man's Hall, where the fraternal organization conducted meetings. Grace Methodist Church is in the background. Many of the city's early retail businesses continue to serve customers of a new generation. (Photo courtesy of Grubb Photo Service.)

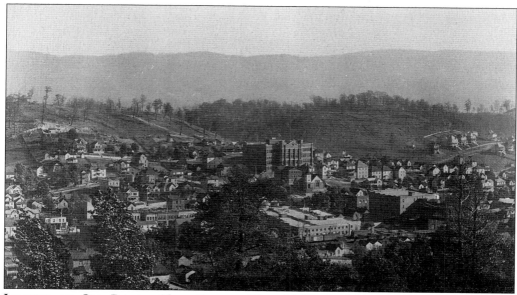

LOOKING AT OLD BEAVER HIGH SCHOOL. The old Bluefield High School shown in this photograph burned in 1925, but was rebuilt in the same location. (Photo courtesy of Grubb Photo Service.)

THE FIRST ST. LUKE'S HOSPITAL. Through the years, Bluefielders have been served by several fine hospitals. The building shown here served as the first home to St. Luke's Hospital, before the facility was moved to a new location on Bland Street. The doctors owned Bluefield Sanitarium, which was the city's largest white hospital. Providence and Brown's hospitals served the African-American community. After St. Luke's moved, the building above became home to the city's Red Front Kresge store. The Kresge "Green Front Store" was located across the street in what is now Landmark Mini Mall. The green front Kresge store had a higher class of merchandise and was more expensive than the red front store. Kresge evolved into K-Mart. (Photo courtesy of Nick Buzzo.)

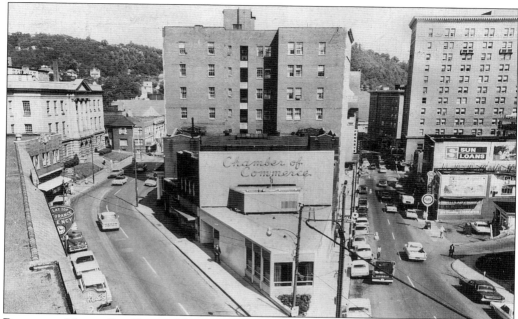

BLUEFIELD MAKES ITS POINT. The old Flat Iron Building was converted into the Greater Bluefield Chamber of Commerce. Although a great deal has changed through the years, the central features in the photograph, including the West Virginia Manor to the right and the Bluefield Arts and Science Center to the left, are essentially intact. The Bradman Building (on the left) burned in 1973. (Photo courtesy of Nick Buzzo.)

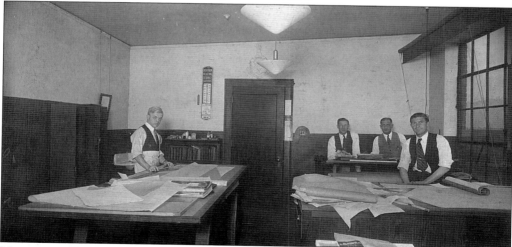

MAN WITH A PLAN. Alexander Blount Mahood (third from the left) left his mark on Bluefield as well as the entire state of West Virginia. He was first hired to remodel the Law and Commerce Building, but in a career that spanned almost 50 years, he designed some of the city's most endearing structures, including Old City Hall, the West Virginian Hotel, several individual residences, most campus buildings at Bluefield State and Concord Colleges, Parkersburg Community College, several dormitories, and the Creative Arts Center at West Virginia University in Morgantown. Mahood's studio was located in the penthouse (seventh floor) of the Law and Commerce Building. (Photo courtesy of the Mahood family.)

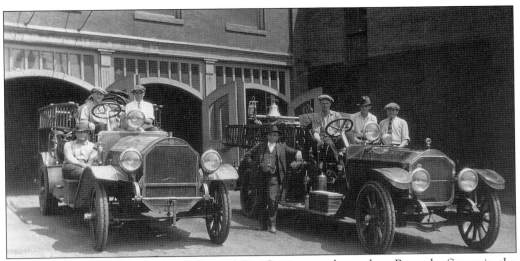

ANSWERING THE CALL. Bluefield's Central Fire Station was located on Roanoke Street in the city's northside when this photograph was taken. The city's No. 2 Station is located on Bland Street. The first Central Station was built following a January 31, 1908 fire, which destroyed the old YMCA and several other buildings on the northside. (Photo courtesy of Captain Darrell Lambert, Bluefield Fire Department.)

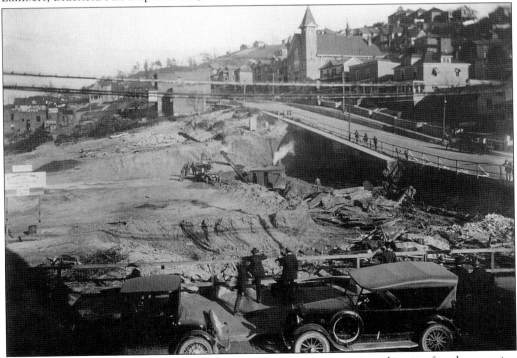

MAJOR PROJECT UNDERWAY. Workmen are shown here preparing the site for the massive 13-story-tall West Virginian Hotel. The building was completed in 1923, and it remains the tallest structure in southern West Virginia. It now provides apartments for low-income elderly families. Note Scott Street Baptist Church behind the construction site. (Photo courtesy of Grubb Photo Service.)

ON THE LINE. The Bluefield Telephone Company was located in this building on Bland Street. Founded in 1893, the Bluefield Telephone Company was one of the earliest companies of the General Telephone Company network. Freeman's Market, a popular fruit and vegetable stand, is in the far right of this photograph. (Photo courtesy of Nick Buzzo.)

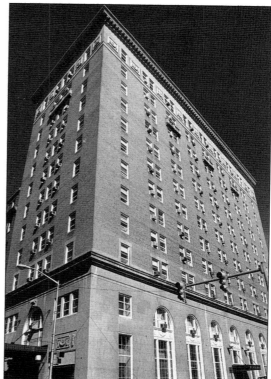

THE SKY'S THE LIMIT. A Bluefield landmark, the West Virginian Hotel completed the city skyline with a dramatic exclamation point when it was completed in 1923. (Photo by the author.)

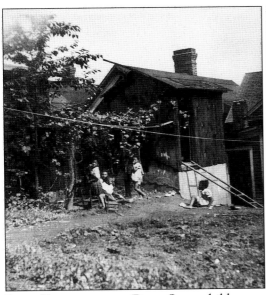

LEFT: YOUNGSTERS AT PLAY. Some children are shown here playing in the backyard of a city residence. (Photo courtesy of the Mahood family.)

RIGHT: CLEAN SWEEP. A woman is shown with her broom in hand sweeping off the back porch. Dust was a major problem in Bluefield with all of the coal rolling through town. (Photo courtesy of the Mahood family.)

BELOW: BACK PORCH. Laundry is hung out to dry on the back porch clothesline shown in this photograph. (Photo courtesy of the Mahood family.)

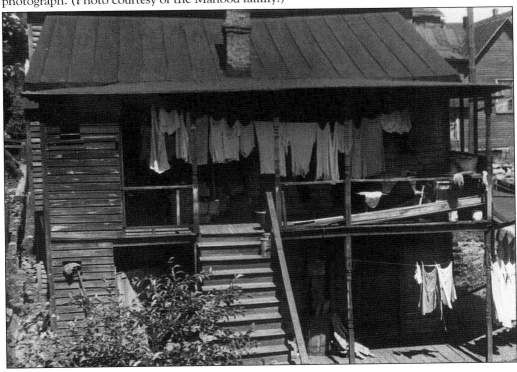

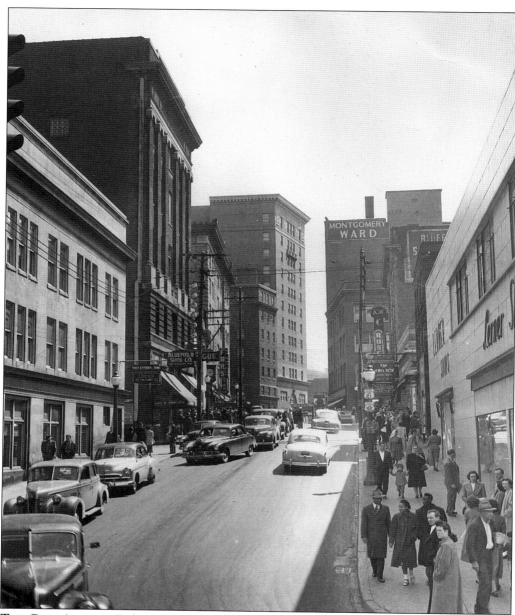

THE CITY ARRIVES. Federal Street looking south, in the heart of downtown Bluefield, was about as cosmopolitan as any place in the United States in the early 1950s. The streets were packed with people, and thanks to the trains arriving and departing almost around the clock, the city was exposed to about every new trend or idea that developed in any part of the world. In 1950, as in the present, Bluefield had the highest percentage of African-American residents of all West Virginian cities. Racial, religious, and cultural diversity has always been one of the city's greatest strengths, but it has also been one of the city's greatest points of division. On the left are the First National Bank, Masonic Temple, J.C. Penny, Flat Top Bank, and Law and Commerce Building. On the right are Lerner's and Jewell Box. (Photo courtesy of author.)

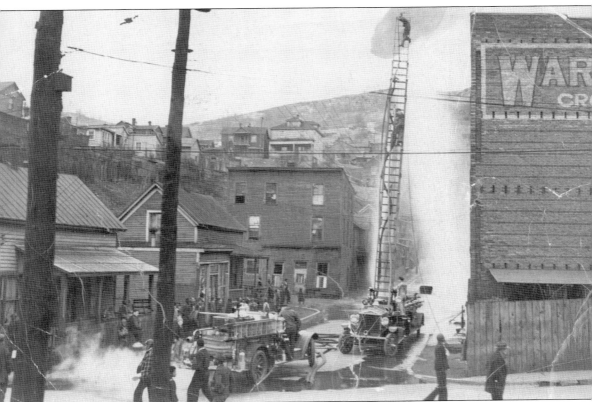

FIRE. Because of their proximity to the coal-fired steam locomotives, wood frame structures, like this one on the city's northside, were highly prone to fire. City firefighters are shown in this 1935 photograph using their 75-foot ladder truck to battle the Peck Street fire. The structure on fire is partially obscured by the Warlick's Furniture Building. (Photo courtesy of Captain Darrell Lambert, Bluefield Fire Department.)

NURSES QUARTERS. The building shown here on the corner of Ramsey and Russell Streets was constructed by David E. Johnston, but served for years as home to the nurses school associated with the Bluefield Sanitarium, located next door. (Photo courtesy of Nick Buzzo.)

MORE POWER TO YOU. The old Bailey Building is located on Bland Street and now serves as American Electric Power's Bluefield Division headquarters. Previous tenants have included the Pocahontas Operators Association and the Baldwin-Felts Detective Agency. (Photo by the author.)

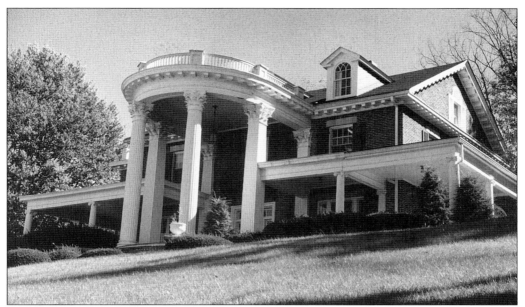

STATELY MANSION. The Harry Wall home on Spring Grove Avenue in South Bluefield is one of the mansions designed by Alex Mahood. Wall was a railroad contractor. The Feuchtenberger family later purchased and remodeled the home. The Feuchtenbergers had a highly successful bakery business and supplied Betsy Ross products throughout the region. (Photo by the author.)

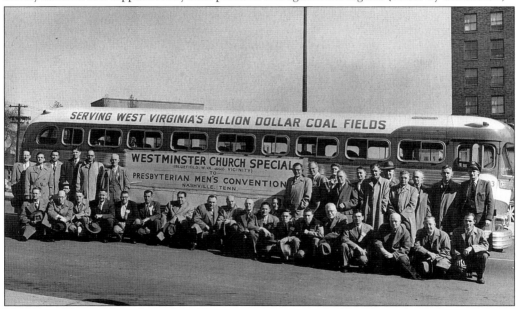

NASHVILLE BOUND. Members of the Westminster Presbyterian Church are shown here preparing to travel to the annual Presbyterian Men's Convention. The group chartered one of Jack Craft's Consolidated Bus Line buses for the journey. Among the notable Bluefielders pictured are Dick Borden (front row, fifth from left), Eddie Steele (front row, fourth from right), Joe Hoge (standing, seventh from left), and Dr. Pat Patterson (position unknown). (Photo courtesy of H. Edward "Eddie'" Steele.)

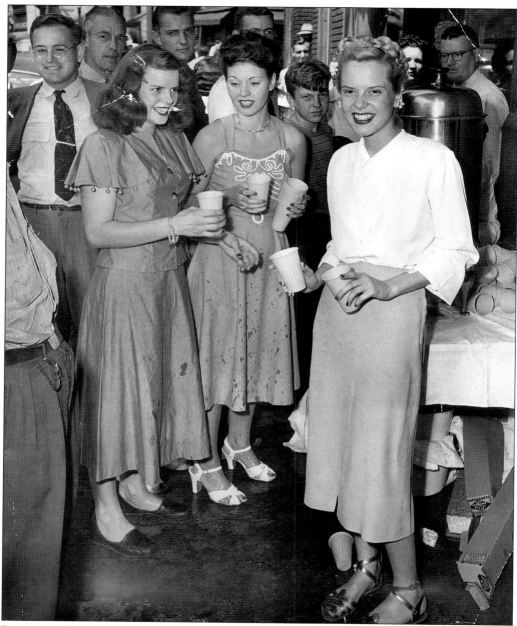

LEMONADE ESCAPADE. Mrs. Roy "Flip" Scales (left) and two fellow "Lemonade Lassies" are shown here distributing free lemonade as part of the Greater Bluefield Chamber of Commerce's weather-related publicity stunt. In 1939, Eddie Steele dreamt up the idea of giving away free lemonade when local temperatures exceeded 90 degrees. However, due to back-to-back mild summers, the chamber wasn't forced to make good on its promise until 1941. Sugar shortages during World War II sidetracked the promotion for a short while, but it still continues today. Some of the men pictured include Harry Wall (far left), Bob Crockett (second from left), and Dick Borden (far right). (Photo courtesy of H. Edward "Eddie" Steele.)

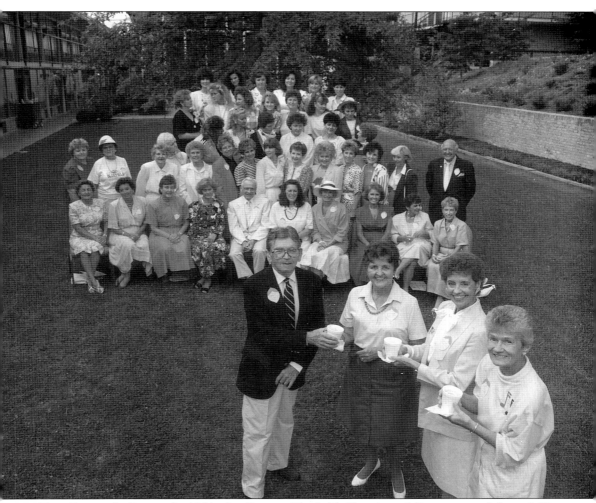

THIS LEMON IS SWEET. In 1991, the Greater Bluefield Chamber of Commerce celebrated 50 years of the lemonade publicity stunt. Eddie Steele is shown here receiving a glass of lemonade from one of the first lassies, Shirley Peters. Along with a Lemonade Lassie reception, the chamber of commerce hosted a "Lemon Toss" off the top of the West Virginia Manor, had a Lemon Parade, watched as members of the Bluefield Baby Birds Rookie League baseball team warmed up with lemons, and even lost $500 in an ill-fated raffle of a dilapidated Edsel. (Photo by Melvin Grubb.)

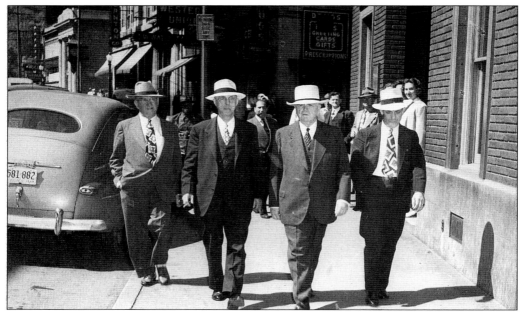

UNION MAN. United Mine Workers president John L. Lewis (third from the left) is shown here walking with three of his associates on Federal Street on their way to the 1949 coal talks with the Bituminous Coal Operators Association. That year's meeting was held in the West Virginian Hotel. (Photo by Melvin Grubb.)

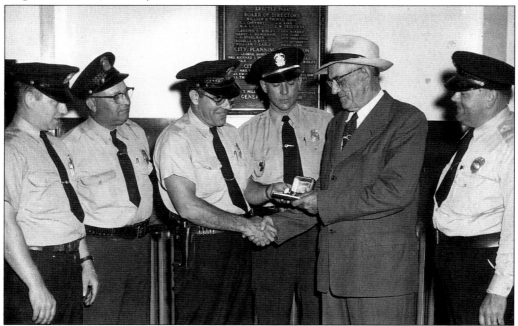

JOB WELL DONE. Paul Oliver is shown here receiving a watch in recognition of his years of service to the city police department. Shown, from left to right, are the following: Oakey Asbury, Auten Meadows, ? Tabor, Leon French, Oliver and Ted Land. (Photo courtesy of Nick Buzzo.)

THE OLD SCHOOL. Ramsey School is the city's oldest school, with roots dating to 1889, when Miss Nannie George accepted the position as the school's first principal. Ramsey was home to the city's board of education when it operated a self-contained school system. American humorist Will Rogers once performed on Ramsey's stage, and the school was written up in *Ripleys Believe It Or Not*, because it has entrances on seven different levels. (Photo courtesy of Nick Buzzo.)

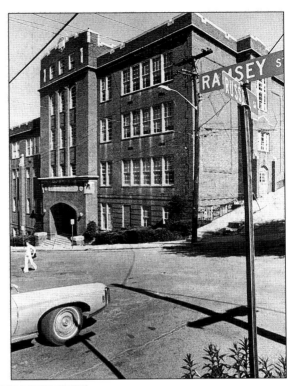

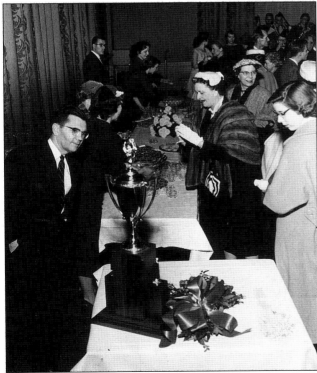

BLUEFIELD ROYALTY. Eddie Steele (left) is shown admiring the trophy won by Phyllis Whiteneck, the first Junior Miss America. The reception was held March 4, 1958. (Photo by Melvin Grubb.

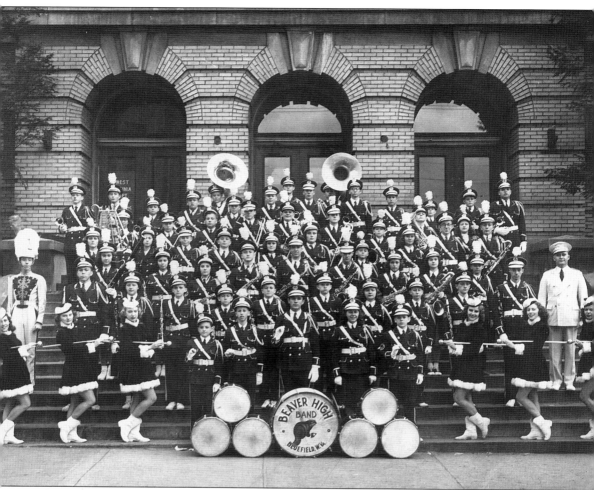

MELODY MAKERS. Members of the Beaver High School Marching Band are shown posing for a photograph in front of the old city hall, now the Bluefield Arts and Science Center. The band was, and continues to be, a top-notch unit, which through the years has earned its share of high honors. (Photo courtesy of Nick Buzzo.)

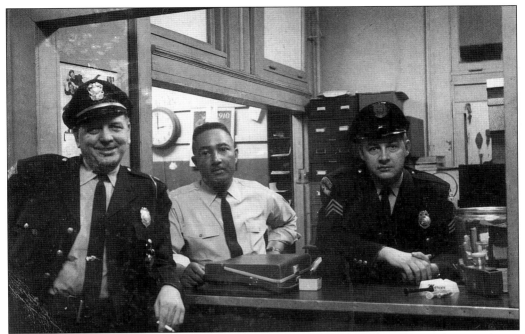

TOP COP. Bluefield's first black police chief, Andrew Dodson (center), is shown above with two unidentified officers. Dodson was one of the city's most highly respected officers and was very successful as chief. (Photo courtesy of J. Franklin Long.)

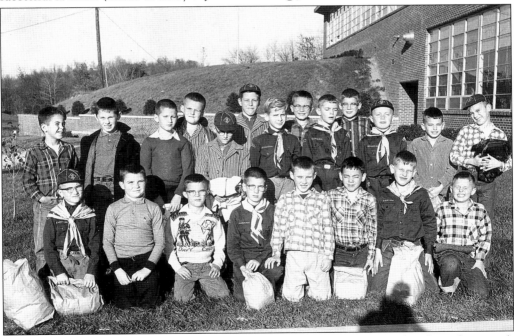

GOOD SCOUTS. A den of Bluefield Cub Scouts is shown here grouped together for a photograph behind Memorial School in South Bluefield. Scouting has long been a favorite activity of city young people. (Photo courtesy of Nick Buzzo.)

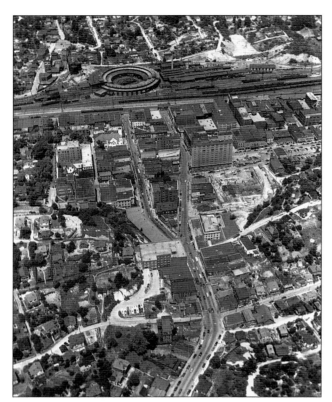

CITY ON THE MOVE. This dramatic aerial view of the city taken in the late 1940s shows Bluefield at its peak. The Norfolk & Western roundhouse looks almost like the Coliseum in Rome. The big construction site near the West Virginian Hotel was the Scott Street Parking Garage, built in 1947. (Photo by Melvin Grubb.)

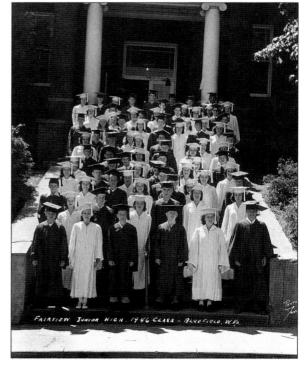

ON TO THE NEXT LEVEL. Students of the 1946 graduating class of Fairview Junior High School appear in full graduation attire. Fairview was one of the feeder schools into Beaver. (Photo courtesy of Nick Buzzo.)

BUSY STREETS. Commerce Street in the late 1950s was a busy place. Note the Granada Theater in the upper left quadrant and Commercial Printing on the right. (Photo courtesy of the Mahood family.)

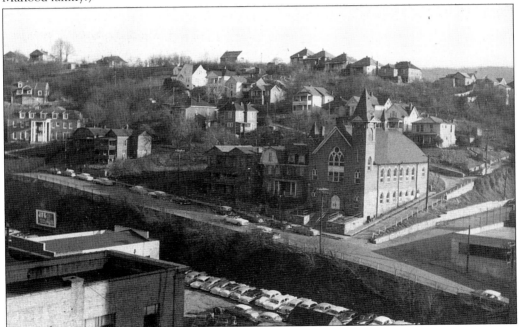

CHURCH ON THE HILL. Scott Street Baptist Church has served the city's African-American community for more than 100 years. On the left side of this photo stands the old Providence Hospital (white columns), one of the city's two hospitals for African Americans. (Photo courtesy of the Mahood family.)

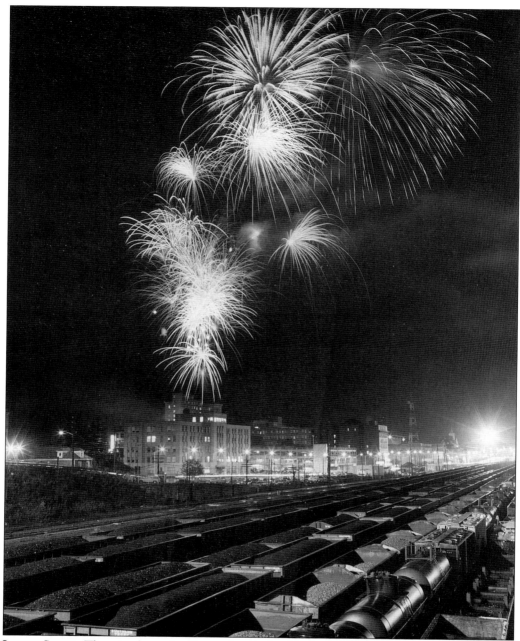

LIGHT SHOW. The city hosted a fireworks display by the Craft Family Shooters as part of the first Mountain Festival, Memorial Day weekend, 1985. Melvin Grubb's dramatic multi-exposure shot of this incredible display is one of the most compelling images of the city. (Photo by Mel Grubb.)

Four

TRANSPORTATION

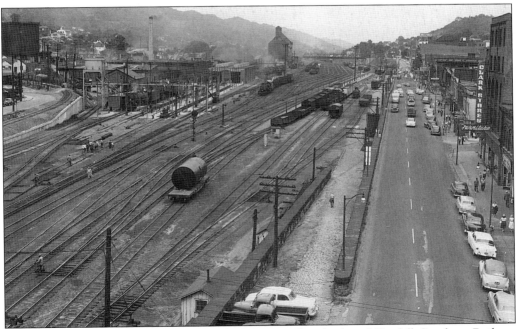

THE BLUEFIELD YARD. Bluefield remains the busiest yard in the (now) Norfolk Southern Railway system. The location of the division's mechanical shops was determined because of the area's natural gravity "hump," creating the highest point on what had previously been the Norfolk & Western mainline. Railroaders used gravity to help collect eastbound coal cars into unit trains. In the early days, coal cars were "draped" over the hump and sent eastward in trains of 100 or more cars. (Photo courtesy of Nick Buzzo.)

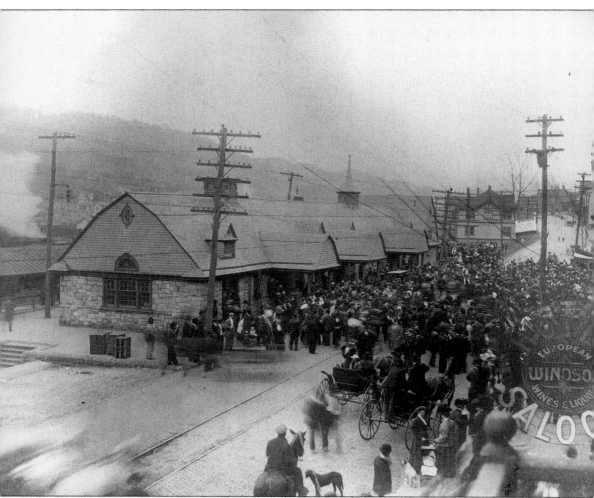

BIG CROWD AT THE STATION. There is no telling what brought the crowd to Bluefield's passenger station on the day this photograph was shot, but it did not always take an arriving dignitary to attract a large group of people. Local merchants took advantage of the rapid freight movement. Jimmy Rantis, who owned and operated Jimmy's Restaurant across from the station, kept an aquarium in the front of his picture window stocked with fresh lobsters that were brought to Bluefield daily from the coast. (Photo courtesy of Grubb Photo Service.)

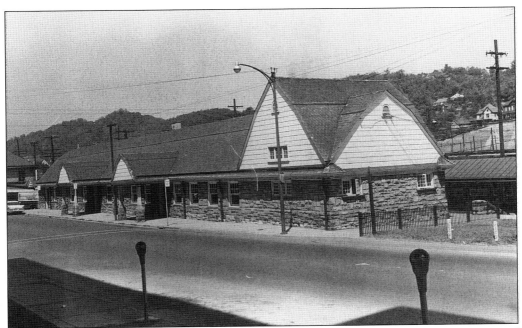

PASSENGERS ARRIVING FREQUENTLY. Bluefield's massive sandstone passenger station was one of the truly remarkable structures in the coalfield. Thousands of people came through the station, some on their way to coal camps, but others planning to seek their destiny in Bluefield. The station was demolished about a decade after passenger service was discontinued. (Photo courtesy of Grubb Photo Service.)

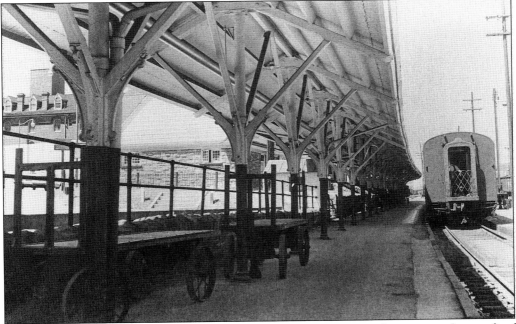

ALL ABOARD. The loading platform of the old passenger station stood witness to thousands of arrivals and departures through the years. (Photo courtesy of Grubb Photo Service.)

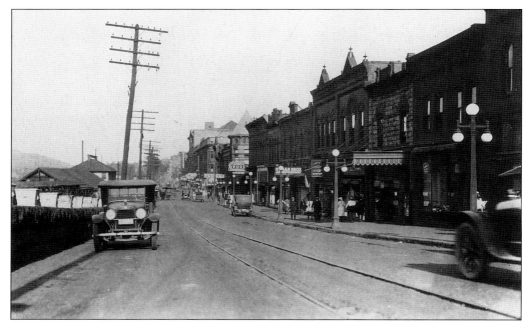

CARS, TRAINS, TRUCKS, AND TROLLEYS. There were plenty of transportation opportunities available to people who visited Princeton Avenue in the city. This photo was taken from Russell Street. (Photo courtesy of Grubb Photo Service.)

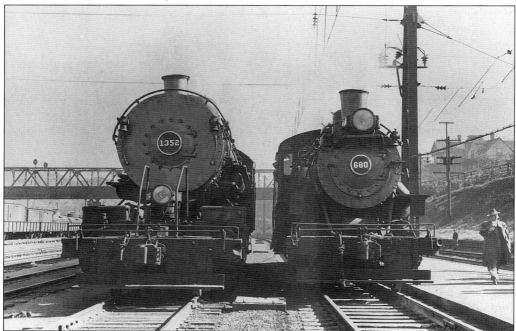

STEAM POWER. The steam locomotives of Bluefield filled the city skies with smoke, but served as a constant reminder of the power of coal. Steam was abandoned in the late 1950s in favor of diesel-powered locomotives, and almost overnight, the 500 N&W employees who worked at the Bluefield roundhouse were out of work. (Photo courtesy of Grubb Photo Service.)

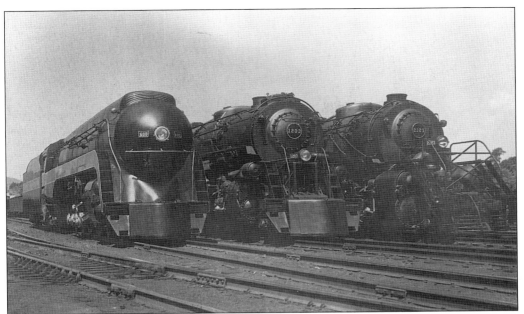

COAL POWER. During the age of steam locomotives, there were all kinds of "engines," including the 600, 1203, and 2121 traveling through Bluefield. (Photo courtesy of Grubb Photo Service.)

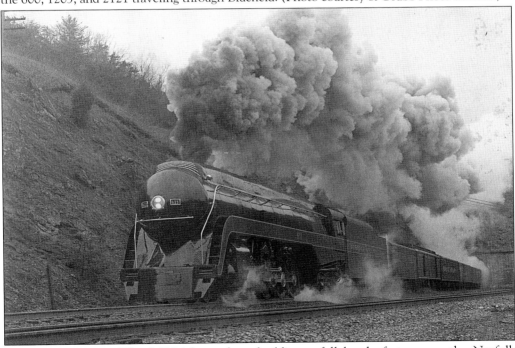

LAST OF ITS KIND. The J-611, shown here building a full head of steam on the Norfolk Southern mainline outside of Bluefield, was the last of the great steam locomotives to work the mainline. This particular locomotive was damaged in a derailment and was in the repair shops when the rest of the steam locomotives were taken out of service. The Northern Southern used the 611 for rail excursions until 1995. (Photo courtesy of H. Edward "Eddie" Steele.)

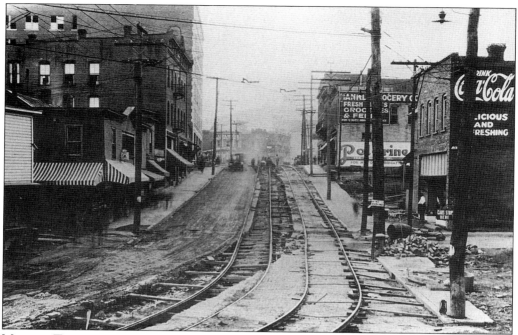

MAKING TRACKS INTO DOWNTOWN. Tri-City Traction crews are shown here laying tracks on Bland Street at the intersection of Jones Street in the heart of downtown. For a point of reference, the Bailey Building, home of American Electric Power's Bluefield Division, is at the top of the grade on the left. (Photo courtesy of Grubb Photo Service.)

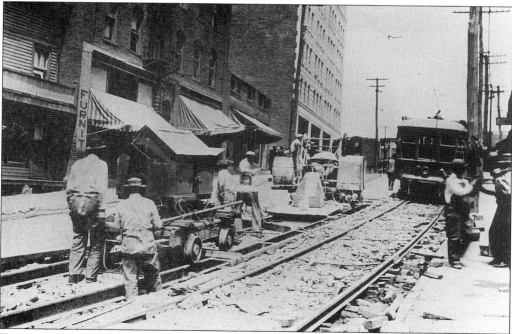

TRACK STARS. Tri-City operated streetcars that provided regular service between Bluefield (Virginia), Bluefield (West Virginia), and Princeton. (Photo courtesy of Grubb Photo Service.)

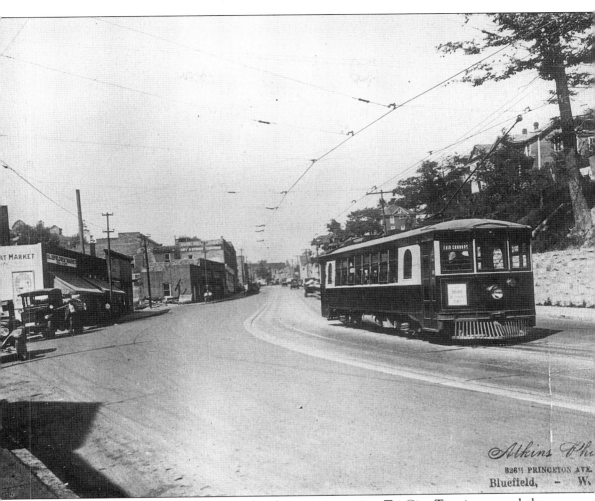

MIDTOWN. In addition to connecting the three communities, Tri-City Traction served the residential areas of Bluefield. The car above was heading south on Bland into town. Note the double streetcar line where trolleys could pass. (Photo courtesy of Grubb Photo Service.)

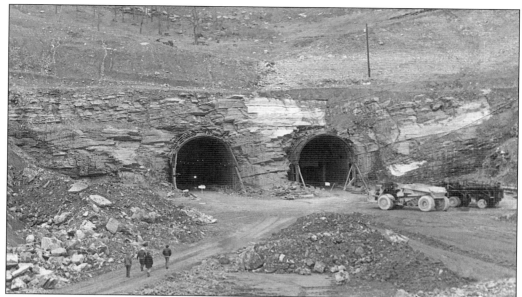

HOLE IN THE WALL. One of the greatest developments in ground transportation came on December 20, 1974, when the East River Mountain Tunnel was opened on Interstate 77. The mountain had been a formidable barrier to north-south travel, but with the completion of East River and the Big Walker Mountain tunnels, the dream of a Great Lakes-to-Florida Highway moved closer to reality. (Photo courtesy of H. Edward "Eddie" Steele.)

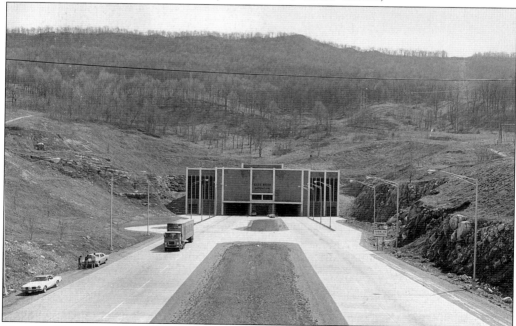

MODERN HIGHWAY. About half of the East River Mountain Tunnel is located in Virginia and about half is in West Virginia. Although the complex control system is located in Bluefield on the West Virginia side, it is staffed by employees of the Virginia Department of Transportation. (Photo courtesy of H. Edward "Eddie" Steele.)

MOVING MEMORIES. A moving crew helps negotiate utility wires on Princeton Avenue at Tazewell Street as a truck hauls the famed *Seven Spot* to its new home in Bluefield City Park. The old *Seven Spot* was in service on the Clinch Valley line and was among the last of the steam locomotives to be removed from service. (Photo courtesy of H. Edward "Eddie" Steele.)

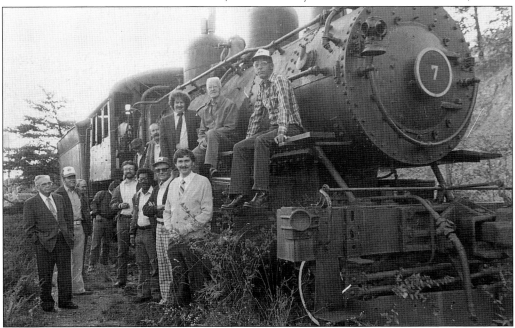

ADOPT A LOCOMOTIVE. Members of the Pocahontas Chapter of the National Railway Historical Society adopted the *Seven Spot* as a chapter project and cleaned up its present location. In recent years, the chapter has collected an old coal hopper car and a caboose that are also in the park. (Photo courtesy of Nick Buzzo.)

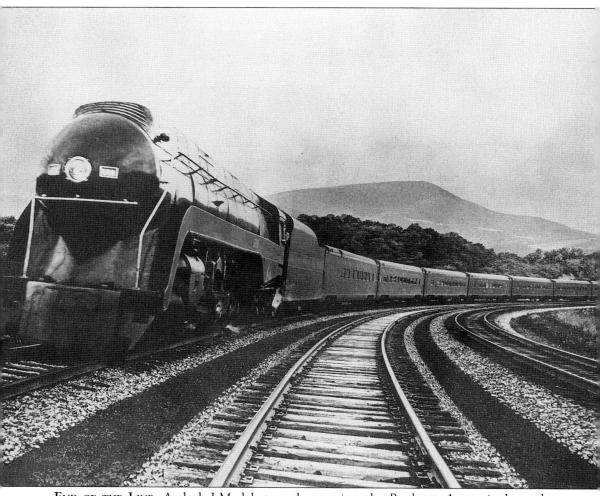

END OF THE LINE. A sleek J-Model steam locomotive, the *Powhatan Arrow*, is shown here pausing on the tracks. The J-611 is now part of Roanoke's Rail Museum, but alas, the rest are gone. The *Powhatan Arrow*, the eastbound train, and *Pocahontas*, the westbound train, ran day trips between Norfolk, Virginia, and Cincinnati, passing the half-way mark at Tip Top in Tazewell County, Virginia. (Photo courtesy of Grubb Photo Service.)

Five

CHAMBER BUSINESS

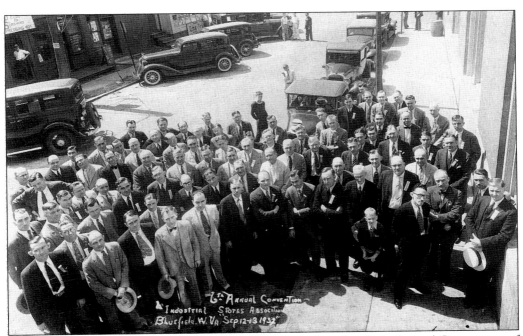

A PLACE OF BUSINESS. In September of 1932, men attending the Sixth Annual Convention of the Industrial Stores Association had their picture taken beside the West Virginian Hotel on the right and Simon's Market on the left. The region's business community provided a vital service to the growing coalfields. (Photo courtesy of Thurman Scruggs.)

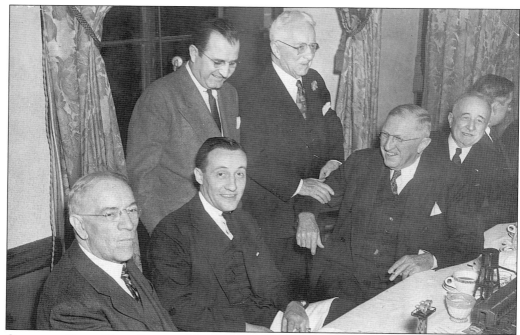

GIANTS OF THEIR TIME. Some real heavy hitters of the business world attended a World War II dinner in spring of 1943 at the West Virginian Hotel. Shown, from left to right, are the following: (seated) Howard Evanson, head of the National Coal Association; Lewis C. Tierney of Mohawk Coal; W.J. Jenks, president of the N&W Railway; and Col. John J. Lincoln, superintendent of Crozer Coal; (standing) Albert Kemper of Bluefield and W.M. Ritter of Ritter Lumber. (Photo courtesy of H. Edward "Eddie" Steele.)

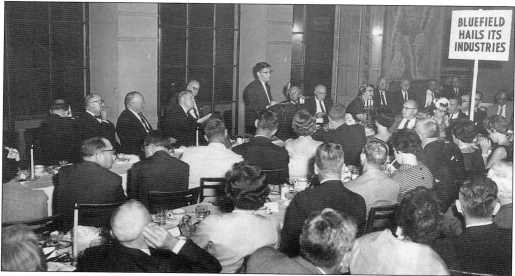

THE CHAMBER MEANS BUSINESS. Eddie Steele is shown here addressing the Greater Bluefield Chamber of Commerce on July 21, 1960. Steele once served as manager of the chamber. The photograph was taken in the West Virginian Hotel ballroom. (Photo courtesy of H. Edward "Eddie" Steele.)

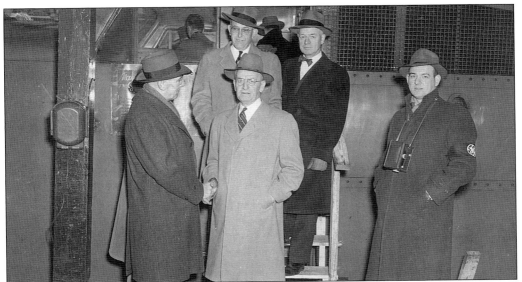

ELECTRIFYING EXPERIENCE. A group of dignitaries gathered at General Electric's "More Power to America" special train that arrived in Bluefield on December 19, 1950. From left to right are the following: C.B. Cliff Sykes of General Electric in Bluefield; Bluefield mayor W.L. Thornton; L.W. Bates of Appalachian Electric Power Company of Bluefield; J. Dodd, manager of the Bluefield Chamber of Commerce; and E.R. Van Dyke of General Electric. (Photo courtesy of H. Edward "Eddie" Steele.)

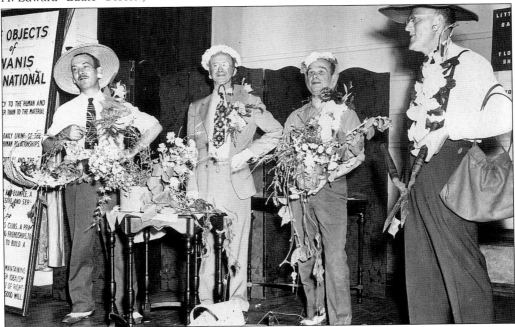

SERVICE CLUBS. Members of the Bluefield Kiwanis Club went through a strange initiation, as evidenced by this photograph. Shown, from left to right, are the following: Bill Goodlow, Asa G. Taylor, Bill McDougle, and D.C. Duncan (Appalachian Power Company safety director). (Photo courtesy of Thurman Scruggs.)

GOOD SPORTS. Bluefield's sporting world was famous in large part because of the exploits of Virgil L. "Stubby" Currence, seen seated at the far left. Currence was sports editor of the *Bluefield Daily Telegraph*, and his unrestrained support for Bluefield's teams made him loved in the city, but often loathed in many surrounding communities. Because of his love for youth athletics, the group of men shown above created a "Stubby Currence Award" to be given annually to an athlete who achieved great success. Shown here, from left to right, are the following: Currence, Beaver Football coach Merrill Gainer, *Daily Telegraph* manager Edward "Ned" Shott, Judge Morton F. Wagner, Norris Kantor, and A.A. "Al" Modena. Currence had a vote in the annual Heisman Trophy award. (Photo from the *Daily Telegraph* archives.)

BLUEFIELD HARDWARE. Officers and employees of Bluefield Hardware are shown here, from left to right, as follows: (front row) Ray E. Ratliff, Searle Layne, John D. Rodrian, Walter Mahaffey, Charles M. Harrell, and G.W. Wagner. The back row includes H.L. Walker, Thurman Scruggs, Nelson Munsey, John L. Hancock, Doug Mattox, and Henry A. Fortune Jr. Bluefield Hardware was one of the great distribution businesses that lined Bluefield Avenue. (Photo courtesy of Thurman Scruggs.)

BELLES FROM ABOVE. The Belle Helicopter Company brought a helicopter to the 1958 Southern Appalachian Industrial Exhibit to try to sell it to Feuchtenberger Bakery. Charles Strachan (far left) and Cap Kembro (far right) took 1958 Miss Bituminus XIV Peggy Tolley and her court for a ride from Wade Field. Shown here, from left to right, are the following: Strachan, Eddie Steele, Carol Todd, Nancy Hughes, Wanda Stout, Tolley, Sarita Matney, and Kembro. (Photo courtesy of H. Edward Steele.)

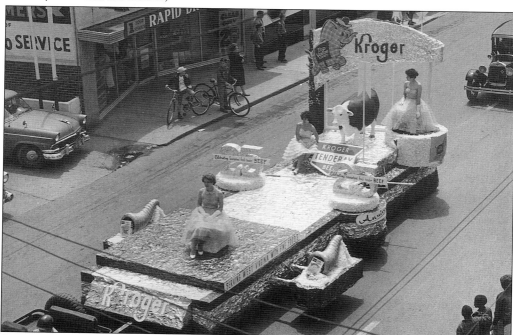

COAL PARADE. The Southern Appalachian Industrial Exhibit parade was always a big event. A float carrying Miss Bituminous candidates is pictured passing through midtown on Bland Street. (Photo courtesy of H. Edward Steele.)

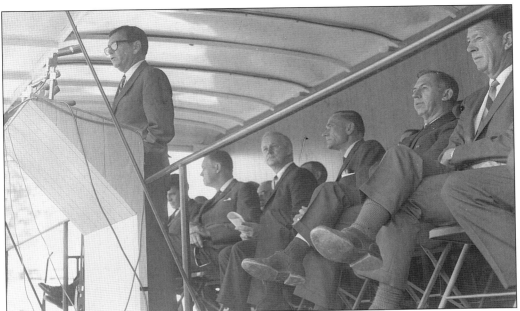

ROAD SHOW. Eddie Steele is shown here addressing a crowd during the Bluefield groundbreaking ceremony of the Great Lakes-to-Florida Highway. Immediately behind Steele is former West Virginia governor Arch Moore. Congressman Jim Kee is to Moore's right. (Photo courtesy of H. Edward "Eddie" Steele.)

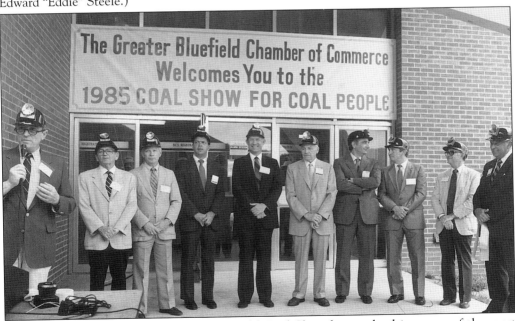

COAL SHOW FOR COAL PEOPLE. The Bluefield Coal Show has evolved into one of the most highly regarded shows of the coal industry. It is held biennially during the second week in September. Shown here, from left to right, are the following: Fred Burton, Eddie Steele, Frazier Miller, Jerry Jackson, Paul Cole, Coal Show general chairman Charlie Peters, Richard Ammar, Nick Ameli, Scott Shott, and Nelson Walker. (Photo courtesy of Melvin Grubb.)

CELEBRATION FOR A ROCKET MAN. Homer H. Hickam Jr., author of *Rocket Boys, A Memoir,* which was made into a major motion picture called *October Sky,* was the keynote speaker at the 1999 annual dinner of the Greater Bluefield Chamber of Commerce. A crowd of almost 1,000 people came to hear Hickam's story of a young man growing up in Coalwood, McDowell County. Hickam's father was superintendent of Olga Coal's mines in Coalwood and was an active volunteer in the Bluefield Coal Shows. (Photo courtesy of Melvin Grubb.)

Six

POLITICS AND WAR

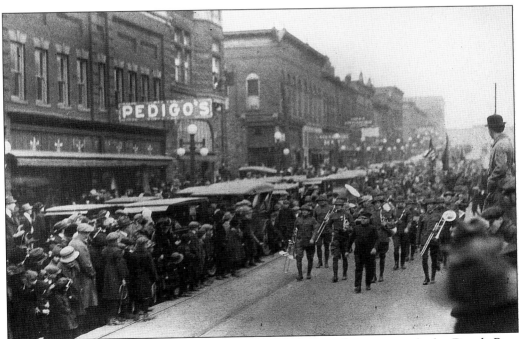

WHEN IT'S OVER, OVER THERE. Thousands of people turned out to watch the Dough Boys returning from World War I, as evidenced by this parade on Princeton Avenue. In addition to sending men to fight the war, the Pocahontas Fuel Company won the contract to supply the U.S. Navy with genuine Pocahontas "smokeless coal," during the war. The photograph shows the front of the Pedigo Building. (Photo courtesy of Grubb Photo Service.)

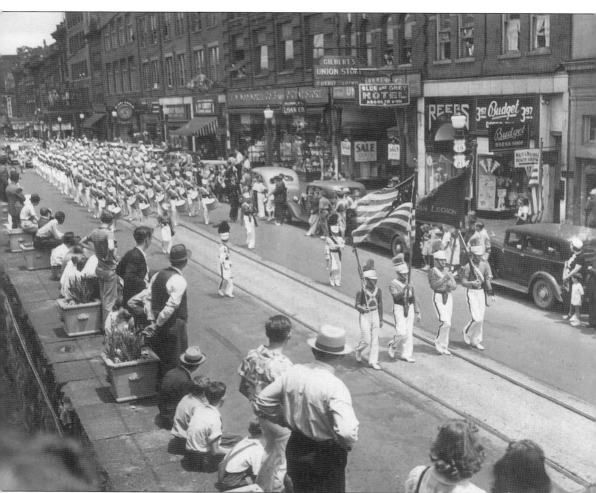

JUDGED AS THE NATION'S BEST. The Bluefield Junior Drum and Bugle Corps was a constant source of pride in the city and, in 1939, achieved national acclaim after winning first in the 40 & 8 parade, first in mixed corps competition, and second in the Junior Division. Dave R. Warden was director of the unit and his daughter, Helen "Sis" Warden, was the drum majorette. The group was formed in the fall of 1932, as part of Bluefield's Riley-Vest Post No. 9 of the American Legion. It is believed to have disbanded sometime in the 1940s. The photograph was taken on the corner of Princeton Avenue and Federal Street. (Photo courtesy of Grubb Photo Service.)

OFF TO FIGHT THE AXIS. Young recruits are shown here on the front steps of old city hall preparing to head off to World War II. Note the racial composition of the young men. Segregation would come after induction. (Photo courtesy of Nick Buzzo.)

THE GREATEST GENERATION. They came from all walks of life to answer their nation's call as visible in this photograph taken from inside city hall. Thurman Scruggs (second from left, kneeling) was one of the thousands of soldiers the area sent to fight in World War II. (Photo courtesy of Thurman Scruggs.)

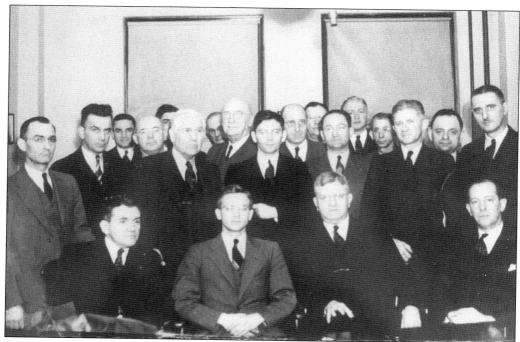

GREEK RELIEF COMMITTEE. When the Nazis over-ran Greece, Bluefield's rather large Greek population formed a "Relief Committee" and enlisted the help of Bluefield's business community in order to provide assistance to the war effort. Greek citizens operated six or seven restaurants in Bluefield and were active in the business community. Pictured, from left to right, are the following: (seated) Jimmy Rantis, Jonnny Dallas, Frank Easley, and E.G. Otey; (standing) Pop Royer, seven unidentified men, Eddie Steele, five unidentified men, Charlie Crews, and two unidentified men. (Photo courtesy of H. Edward "Eddie" Steele.)

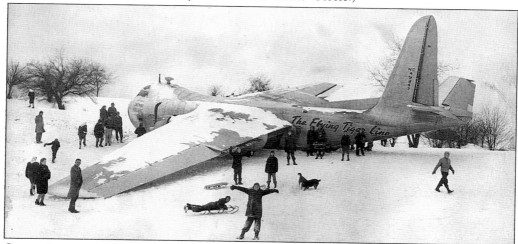

CRASH LANDING. Bluefielders were toasting the end of 1945 when a twin-engine airplane started circling the city in search of a place to land. The plane eventually set down on a fairway of the Bluefield Country Club golf course on January 1, 1946, with no injuries, but lots of excitement for the hundreds of people attending the festivities at the club. (Photo courtesy of Grubb Photo Service.)

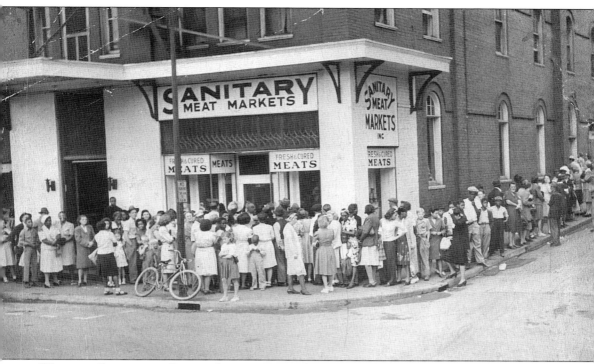

WARTIME SHORTAGES. During the war years, almost everything in the United States was rationed. Here, people are shown waiting in line to pick up their meat ration at the Sanitary Meat Market on the corner of Princeton Avenue and Stewart Street. Note the racial diversity of the people in the line. The war had an impact on all races and creeds, equally. (Photo courtesy of Nick Buzzo.)

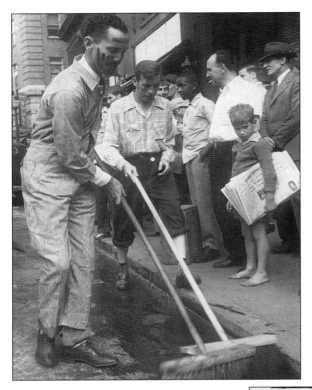

CLEAN UP CREW. As part of their initiation into the 40 & 8, Bruce Walk and Ralph "Sy" Thomason had to sweep the city streets. The 40 & 8 is a society associated with the American Legion that derives its name from the World War I boxcars in France that could haul 40 men and 8 mules to the front. (Photo courtesy of Thurman Scruggs.)

ONE-MAN ARMY. Staff Sergeant Junior Spurrier was said to be the second-most highly decorated G.I. of World War II, second only to Audey Murphy. Sergeant Spurrier's wartime exploits were legendary, but he faced great personal challenges in making the transition to peacetime. To date, there are still no Junior Spurrier buildings, bridges, or highways in Bluefield. (Illustration courtesy of Nick Buzzo.)

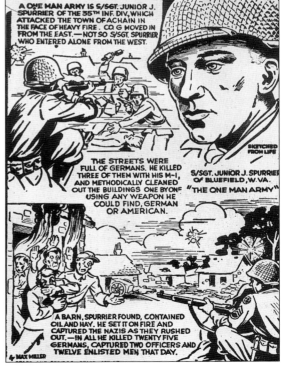

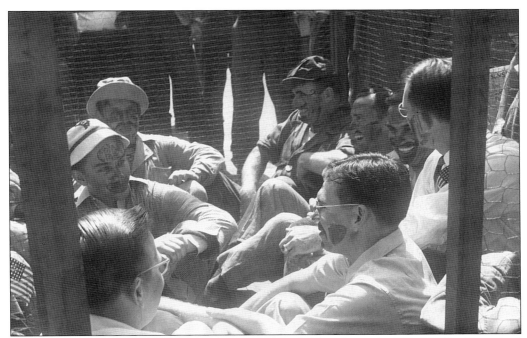

40 & 8-ERS IN A PEN. The 40 & 8 initiation in Bluefield at the end of World War II required the new members to be assembled in a pen. From left to right are the following: Guy Willis (foreground), Dick For, Jack Boyd, Joe "Flapper" Pancake, Eddie Steele (foreground), Bruce Walk, Thurman Scruggs, and Ed Stone. (Photo courtesy of Thurman Scruggs.)

AMERICAN LEGION. After World War II ended, the ranks of Bluefield's Riley-Vest Post No. 9 of the American Legion swelled. Shown, from left to right, are the following: (seated) Jack Wall, Dean Coffey, Ed Stone, Paul Hudgins, Bessie Trent, David Keesee, and Eddie Steele; (standing) Thurman Scruggs, ? Ashworth, Bill Keil, Johnny Coleman, and Bill Cooper. (Photo courtesy of Thurman Scruggs.)

STEPPING OUT. The elegant Henry White (left) is shown leaving his Oakhurst Avenue home with his wife, Mary Harman White (center), and her sister, Mrs. Preston. White was a Naval Academy graduate who could speak five languages fluently. His family became friends with the family of Dr. Wernher von Braun. After the war, von Braun sought out White to translate some of his German books on rocketry into English. Von Braun visited Bluefield a few times and was a big hit among the country club set. (Photo courtesy of Mrs. Marjorie P. Walters.)

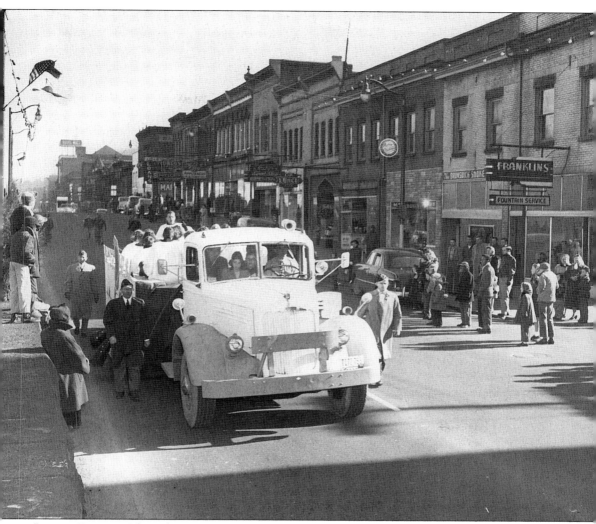

LINE OF PARADE. The Riley-Vest Post No. 9 of the American Legion sponsored this float in the Christmas parade of November 28, 1952. Crowds lined Princeton Avenue at Tazewell Street to catch a glimpse of the units in the parade. (Photo courtesy of H. Edward Steele.)

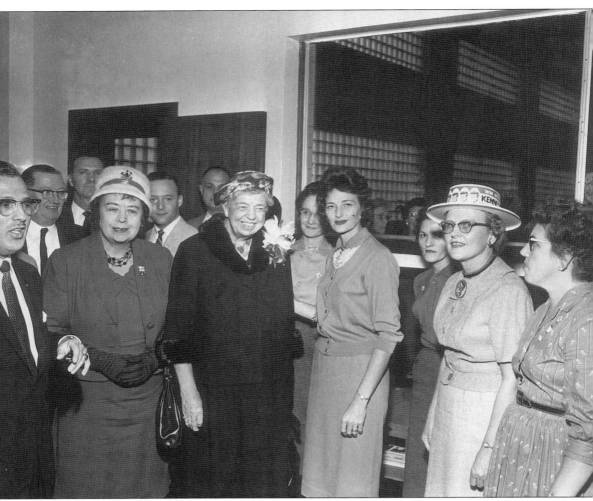

A Visit by the First Lady. Former First Lady Eleanor Roosevelt visited Bluefield during the 1950 primary election stumping for (then) U.S. Senator John F. "Jack" Kennedy. Congresswoman Elizabeth Kee is to the former first lady's immediate left. A pair of notables in the crown include Norris Kantor and Laurence Tierney. Even in 1960, Mrs. Roosevelt was one of the most beloved Americans of her time. (Photo by Melvin Grubb.)

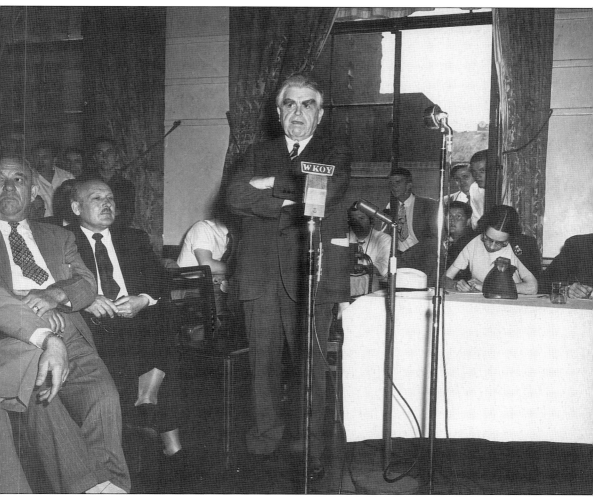

MEET THE PRESS. John L. Lewis, president of the United Mine Workers of America, is shown here meeting with representatives of the press during coal talks in 1949. Because of Bluefield's reputation of having an affiliation with the Baldwin-Felts Detective Agency as well as its image as a coal operators' city, Lewis's visits to Bluefield were rare. This meeting was held in the West Virginian Hotel ballroom. (Photo by Melvin Grubb.)

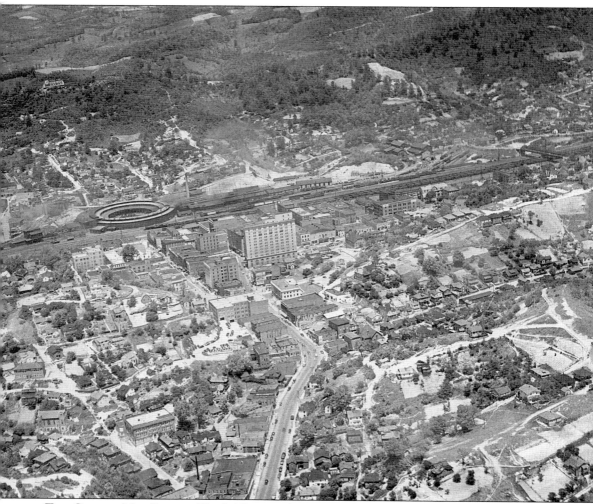

THE CITY IN MID-STRIDE. Bluefield's growth continued to surprise the region. On July 12, 1924, the town of Graham, Virginia, participated in a gala "wedding" celebration that officially changed the town's name to Bluefield, Virginia. Although dramatic growth continued through the next quarter century, the city didn't quite expand all the way to the town. In more recent years, the Virginia-side community is experiencing greater growth than its West Virginia sister. (Photo courtesy of H. Edward Steele.)

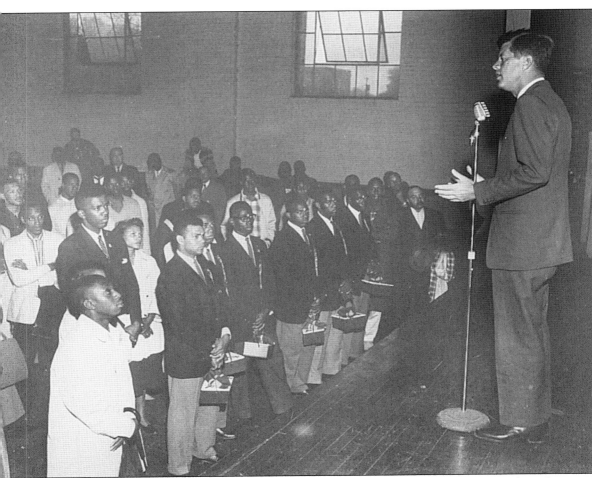

ASK WHAT YOU CAN DO FOR YOUR COUNTRY. In late April of 1960, during the presidential primary, (then) U.S. Senator John F. "Jack" Kennedy saw West Virginia as a pivotal election on his way to winning the Democratic Party's nomination. He is shown here speaking with students of Bluefield State College during one of several campaign visits he made to the Mountain State that year. (Photograph by Melvin Grubb.)

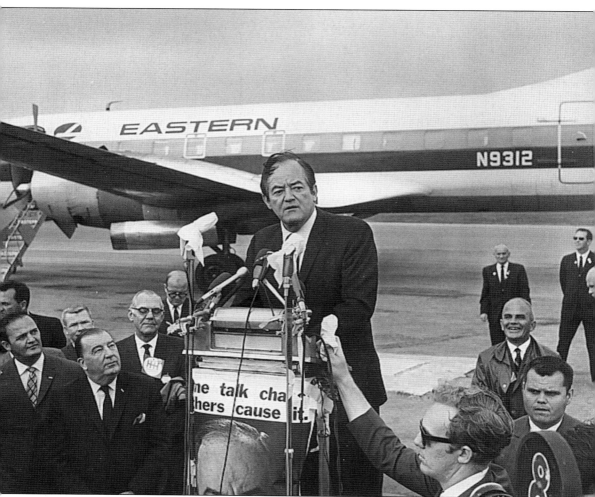

THE SENATOR FROM MINNESOTA. Hubert H. Humphrey was John Kennedy's opponent in the 1960 West Virginia Democratic Primary. The two candidates waged a terrific battle throughout the state with Kennedy emerging victorious and moving on to his party's convention. U.S. Senator Jennings Randolph is pictured second from the left and the balding man on the right is long time Mercer County Commissioner Tate Lohr. (Photo by Melvin Grubb.)

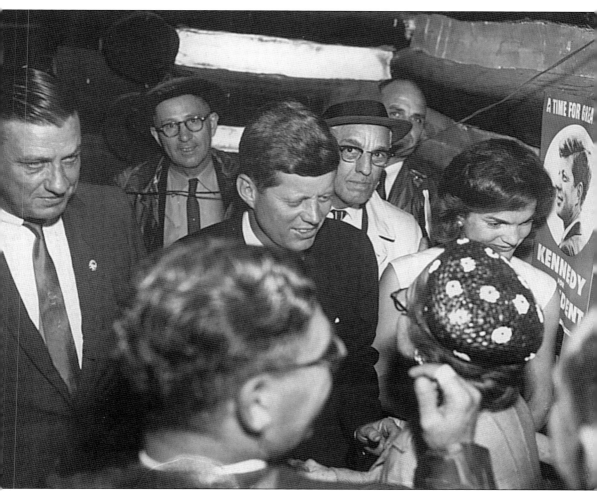

KENNEDY FOR PRESIDENT. After making the rounds with the press in Bluefield and enjoying a luncheon with the Tierney family, John and Jackie Kennedy were the guests at a picnic held by Mercer County Democrats at Glenwood Park. Kennedy's victory in the May 1960 West Virginia Primary proved to the party leadership that a Catholic candidate could carry a traditional Southern Baptist state. When the campaign left, the region was saddled with the name "Appalachia", a term that continues to evoke images of poverty. Bob Crockett (wearing hat) is to Kennedy's right and Franklin Delano Roosevelt Jr. (FDR's son) is on the left. (Photo by Melvin Grubb.)

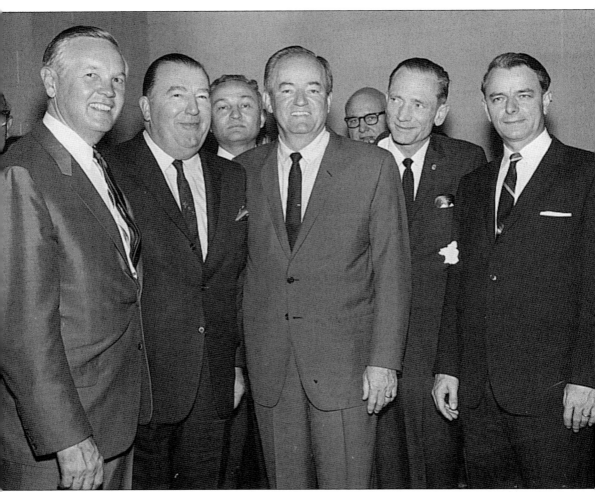

THAT BLUEFIELD SPIRIT. Vice President Hubert Humphrey returned to Bluefield in 1965 to join in the celebration of Bluefield being named an All-American City. A group of Bluefielders carried "The Bluefield Story" to San Francisco on November 19, 1964, and earned the coveted honor. Shown here, from left to right, are the following: (front row) former West Virginia governor Hulett Smith, U.S. Senator Jennings Randolph, Hubert Humphrey, U.S. Rep. James Kee (Democrat-West Virginia, Fifth District), and U.S. Senator Robert C. Byrd (Democrat-West Virginia); (back row) Dr. Nicholas Krupey, Dr. Michael Krupey, and Sid Barksdale. (Photo by Melvin Grubb.)

HIGH SEAS. Vice Admiral Douglas Katz was a 1961 graduate of Bluefield High School who attended the U.S. Naval Academy, graduating in 1965, and went on to have a highly successful career in the Navy. When he retired on June 6, 1997, as a three-star admiral, he was in command of the Atlantic Surface Fleet. (Courtesy of U.S. Navy.)

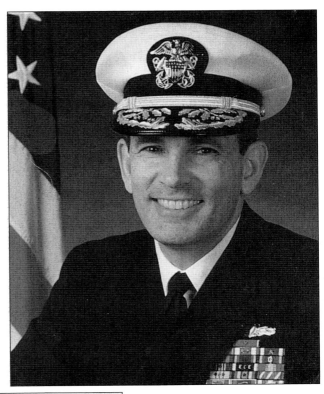

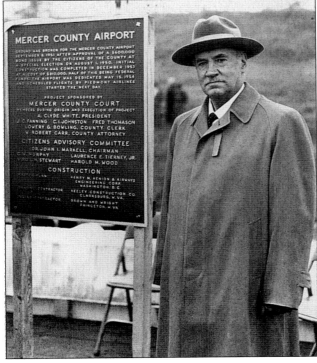

HELICOPTER MAN. Igor Sikorsky, inventor of the modern helicopter, was the keynote speaker at the May 15, 1954 dedication of the Mercer County Airport. Among other ties to Bluefield, Henry White was in Sikorsky's sales staff in the early 1930s. (Photo by Melvin Grubb.)

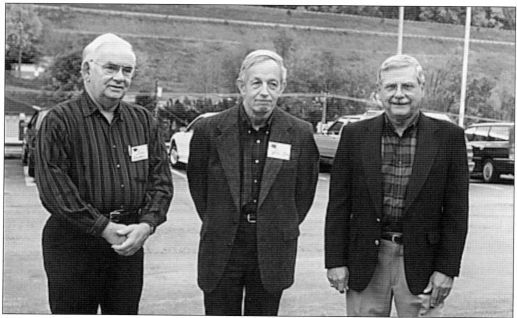

BRAIN TRUST. Dr. John Forbes Nash Jr., 1994 Nobel Laureate in Economics, is shown here flanked by Dr. John Louthan (left) and Dr. Ed Williams, all classmates of the Beaver High School Class of 1945. The men were attending their 50th class reunion in 1995. (Photo courtesy of Eva Easley.)

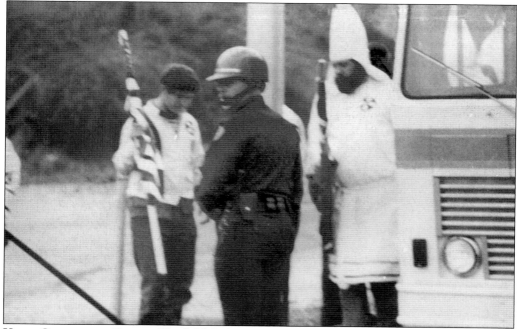

KLAN GATHERING. Former Bluefield Police Department lieutenant Kelly Walls is pictured watching Klansmen get off a bus in preparations for a 1987 Ku Klux Klan rally and march in Bluefield. (Photo courtesy of Kelly Walls.)

Seven

ARTS AND ENTERTAINMENT

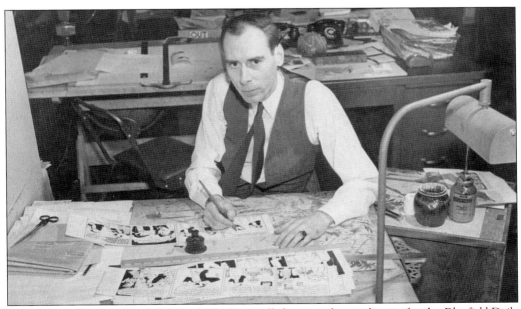

DRAWING A CROWD. Randall "Rand" Taylor, staff photographer and artist for the *Bluefield Daily Telegraph*, made an impact in the newspaper art world. After marrying the newspaper's society editor, Carol Douthat, Taylor moved to New York, where both enjoyed successful newspaper careers with the *New York World Telegram*. Taylor's "Homer Hoopee" cartoon strip was nationally syndicated by the Associated Press. Douthat was the staff reporter at the University of Louisiana student newspaper that exposed Governor Huey Long's corrupt administration. She was driven out of Louisiana for her efforts. (Photo courtesy of Nick Buzzo.)

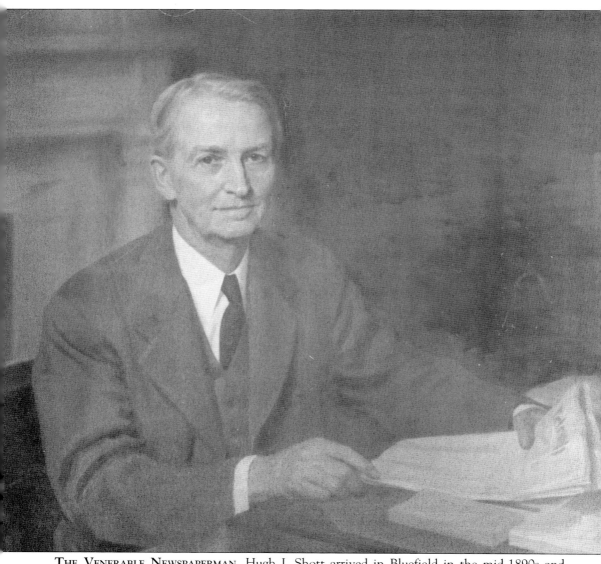

THE VENERABLE NEWSPAPERMAN. Hugh I. Shott arrived in Bluefield in the mid-1890s and selected it as his hometown. In 1896, he bought out his partners in the *Bluefield Telegraph*, and started publishing a daily newspaper under the *Bluefield Daily Telegraph* banner on January 16, 1896. Shott's "Good Morning" columns that appeared on the front page of the newspaper spelled out his philosophy of hard work, loyalty, and thrift. He demanded a great deal of the people with whom he worked and was not afraid of hard work himself. Shott was a staunch Republican, but held a union card as a linotype operator. He served in both the U.S. House of Representatives and the U.S. Senate (Photo courtesy of *Bluefield Daily Telegraph* archives.)

SONS. James H. "Jim" Shott was an innovative leader of the city's business community as well as a leader in communications. He led the fight to establish a television station in Bluefield and organized the Bluefield Gas Company, among other accomplishments. (Photo courtesy of *Bluefield Daily Telegraph* archives.)

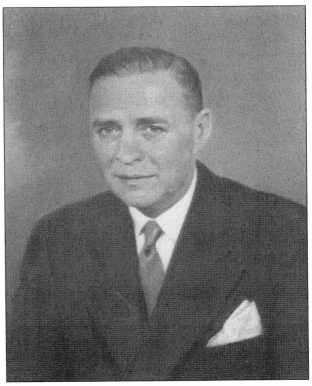

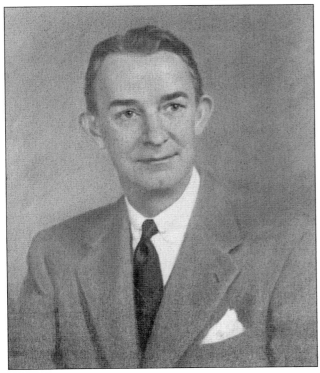

NEWSPAPERMAN. Hugh I. Shott Jr., took over the operations of the newspaper after his father's death in the early 1950s. Through his leadership, the *Bluefield Daily Telegraph* grew despite the region's changing fortunes. (Photo courtesy of *Bluefield Daily Telegraph* archives.)

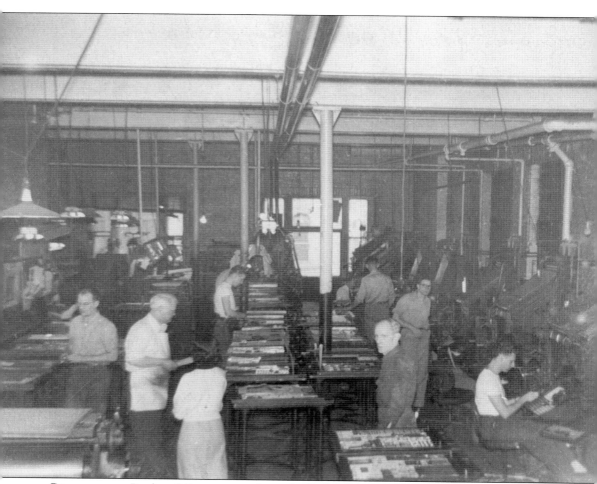

COMPOSITION. Banks of linotype machines kicked out hot lead type in the very bowels of the *Bluefield Daily Telegraph*'s composing room. Although most of the employees could not be identified, the young man making up a "form" and wearing a t-shirt in the middle of the photograph is Dave Ryan, who retired in 1999. For more than a century, the *Bluefield Daily Telegraph* has served as a window to the world for the people of southern West Virginia and southwestern Virginia. (Photo courtesy of *Bluefield Daily Telegraph* archives.)

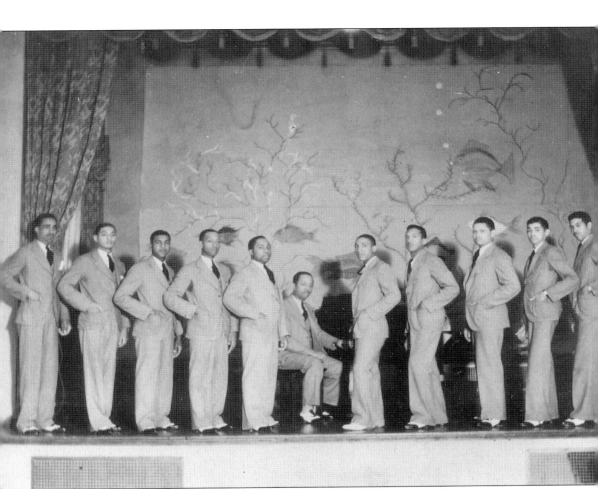

HOT JAZZ IN BLUEFIELD. The West Virginia Collegians were one of the hottest bands to come out of the city. Managed by Bluefield dentist Dr. Ernie Martin (seated at the piano), the Collegians performed for appreciative audiences throughout the region using charts made up by Dr. Martin's lifelong friend, Edward "Duke" Ellington. Shown here, from left to right, are the following: ? Carter, Doug Anderson, Braxton Mitchell, J. Howard Abbott, Ben Moore, Martin, Sidney Few, Trucksie Sinkford, Fred Dodson, Warren Glenn, and Dorothy Wright. (Photo courtesy of Joseph Bundy.)

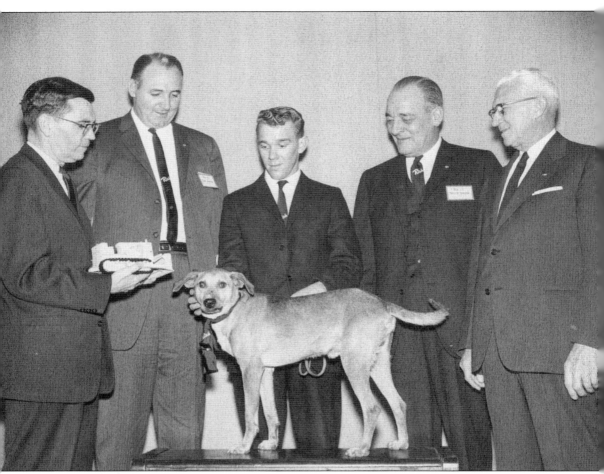

TALE OF BROWNIE THE DOG. In 1961, Burl Osborne was an Associated Press reporter assigned to the AP's Bluefield Bureau. Osborne was a talented writer who knew a good story when it came along, so when he heard that a dog named "Brownie" was trapped in an abandoned mine shaft near Gilbert, West Virginia, he put his efforts behind covering the rescue efforts. The story gained national attention and contributions as well as offers of support. Bluefield-based Rish Equipment dispatched a bulldozer to dig the dog out. Brownie and his master, Dick Hatfield, appeared on three national television shows including *What's My Line?* Osborne went on to become editor/publisher of the *Dallas Morning News*. Shown here at the Rish Equipment sales meeting of January 1962 are, from left to right, the following: Eddie Steele, Chap Johnson, Brownie, Dick Hatfield, Taylor Frazier, and Lon Rish.

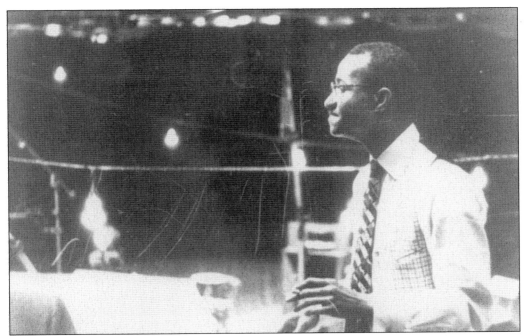

SMOOTH. The great Maceo Pinkard, born in Bluefield on June 27, 1897, and died in 1962, was one of the greatest composers of the Harlem Renaissance. He had two number one hits, "Sweet Georgia Brow," (1925) and "Give Me a Little Kiss" (1926), but contributed many other songs to the world including "Mammy 'O Mine," "Sugar," "Sweet Man," "Lisa," and scores of others. (Photo courtesy of Joseph Bundy.)

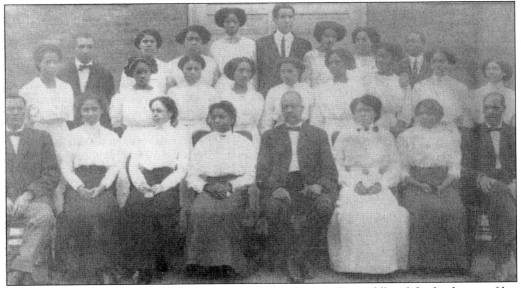

MUSICAL MEMORIES. Maceo Pinkard is pictured standing in the middle of the back row of his 1913 class at Bluefield State College. Along with Pinkard, contemporary artist Bobby Benson went on to fame as the keyboardist for the Ink Spots and composed "Your Feet's Too Big," a song made famous by Fats Waller. (Photo courtesy of Joseph Bundy.)

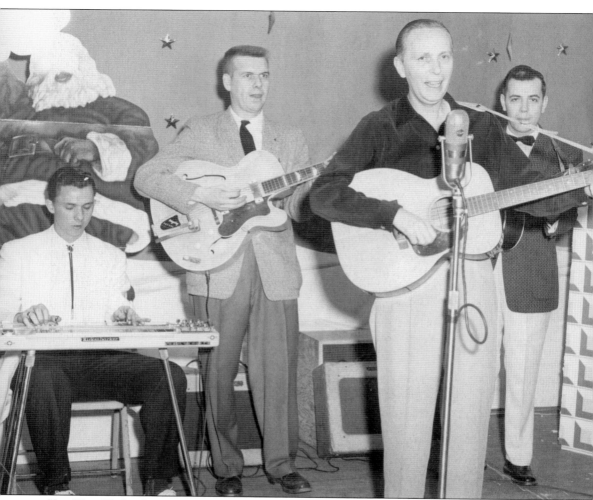

YEE HAW!!! Gordon Jennings, at the microphone above, made a return to Bluefield to sing a few songs at the annual Community Christmas Tree celebration. The backing musicians for that performance were Jack Altizer, King Edward "Smitty" Smith, and Cecil Surratt. Jennings was one of the early country stars who spent time with WHIS Radio. (Photo courtesy of Cecil Surratt.)

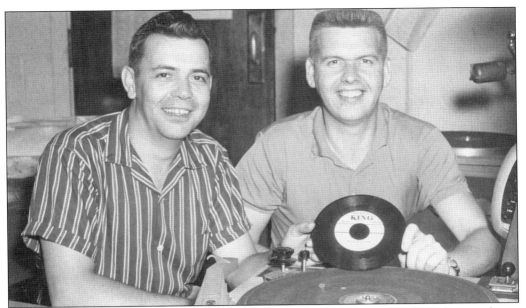

THE BIG TIME. Cecil Surratt and Smitty Smith are shown here at WHIS Radio's studio in the mid-1950s soon after their first release on King Records of Cincinnati. While they had a contract, both decided against living the life of road musicians. (Photo courtesy of Cecil Surratt.)

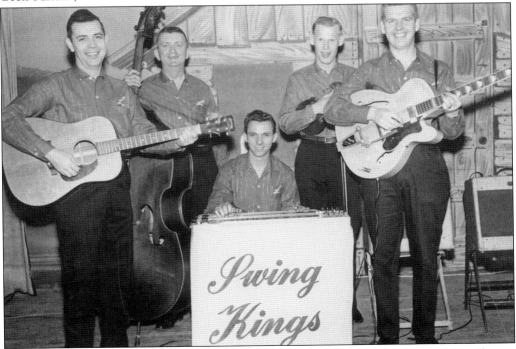

THE ORIGINAL SWING KINGS. Bluefield's top country music band was the Swing Kings. Shown, from left to right, are the following: Cecil Surratt, Warren Blankenship, Jack Altizer, Buck Dillon, and Smitty Smith. (Photo courtesy of Cecil Surratt.)

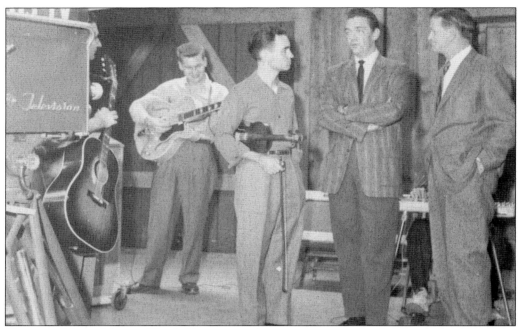

COUNTRY MUSIC MECCA. Bluefield was a regular stopping point for the top performers in the country music world like Carl Smith and Red Sovine, shown above in the WHIS-TV studio. Pictured, from left to right, are the following: Darnell Miller, Smitty Smith, Bud Kurtz, Smith (who made the national charts with "Hey Joe"), and Sovine (who gained fame through his trucker songs like "A Tombstone Every Mile" and "Gitty Up Go"). (Photo courtesy of Cecil Surratt.)

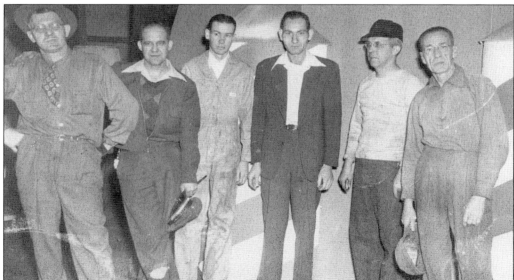

POSITIVE PROJECTIONS. Bluefield's movie projectionists were a tight-knit group. They worked the Granada, State, and Colonial theaters to the delight of their patrons. The two men on the left-hand side of the picture are "Sleepy" Broyles and Glen Brewer. The other four gentlemen are not identified. (Photo courtesy of Nick Buzzo.)

104

SCOOP AND SNOOP. By far, the most popular television program in the early days of local broadcasting was the *Scoop and Snoop Show*, featuring O.C. "Scoop" Young (left) and Ray "Snoop" Brooks. Young was a newspaperman who was working in radio when WHIS-TV went on the air. Brooks happened to be a radio technician at the time. Together, they made live-broadcasting magic with overstated deadpan reactions and witty repartee. Their job was to introduce cowboy movies, but the show's appeal came from Young's straightman delivery on commercials and skits and Brooks's persistent desire for an elusive RC Cola. (Photo courtesy of Nick Buzzo.)

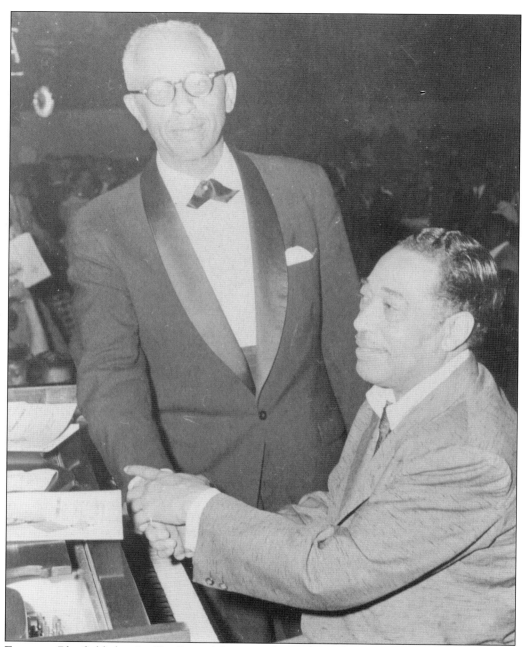

FRIENDS. Bluefield dentist Dr. Ernie Martin is shown here shaking hands with his lifelong friend, Edward "Duke" Ellington. Dr. Martin and his associate Dr. P.R. Higginbotham moved to Bluefield and married sisters. Both men maintained close ties with national events in the African-American community and worked to bring some of the best performers into the area. When Ellington came to Bluefield, he stayed with Martin in his Jones Street residence. (Photo courtesy of Virginia Hebert.)

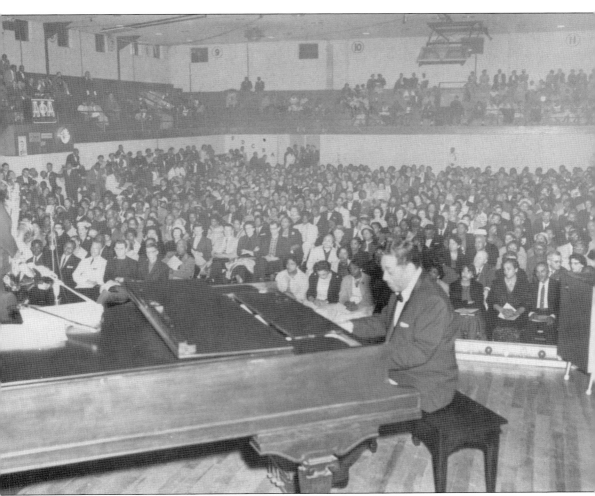

ROYALTY OF SWING. Edward "Duke" Ellington performed at this concert in Bluefield's city auditorium on December 12, 1966, to coincide with his joining the Alpha Phi Alpha Fraternity of Bluefield State College. Ellington's selections for the evening included "Black and Tan Fantasy," "Creole Love Call," "The Mooch," as well as "Satin Doll," "Sophisticated Lady," and a medley of his hits. (Photo courtesy of Virginia Hebert.)

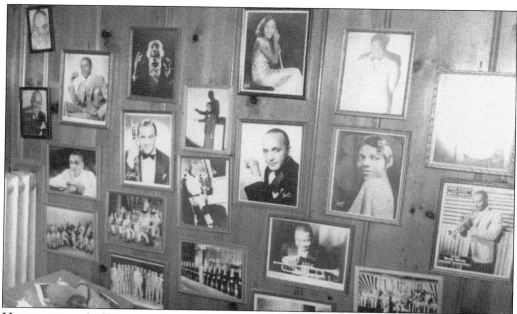

Higginbotham's Wall of Fame. Dr. Peyton Randolph Higginbotham had a photograph collection of all the great performers who traveled through the city. Louis Armstrong, Benny Goodman, Cab Calloway, Chick Webb, and others stayed with the Higginbothams as they were passing through. When the police came to break up an early morning jam session featuring Fats Waller, Dr. Higginbotham related that Waller advised, "Don't give them your right name." (Photo by the author.)

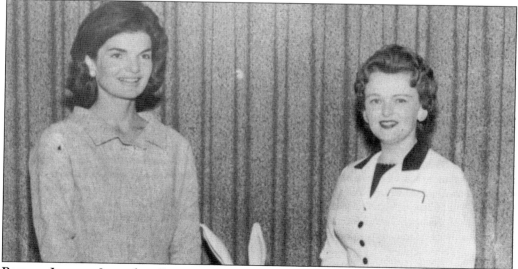

Pair of Jackies. Jacqueline Bouvier Kennedy Onassis was a guest on Jackie Oblinger's daily television program on WHIS-TV, *Woman's Whirl*, in April of 1960. The interview would be the future first lady's first hour-long television interview. The appearance was orchestrated by her brother-in-law, (now U.S. Senator) Ted Kennedy, as well as other publicists. At the time of the interview, Mrs. Kennedy was six weeks pregnant with her son, John F. Kennedy Jr. (Photo courtesy of Jackie Oblinger.)

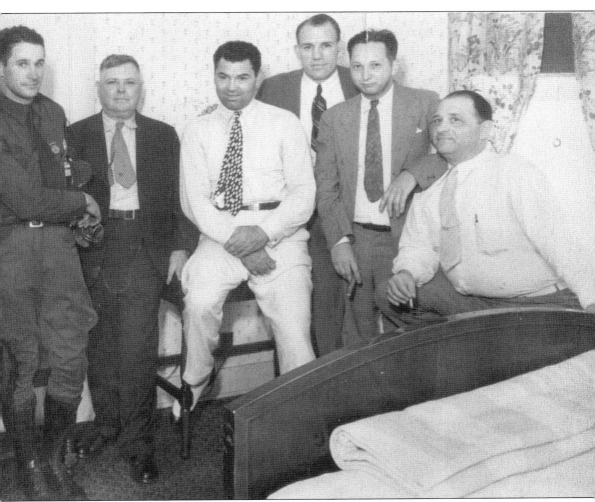

PROMOTERS. Ralph Weinberg (far right) was the city's best-known promoter. He came to Bluefield in the mid-1920s from Baltimore and immediately established a network of theaters throughout the South, where he could book the big-name African-American bands of the time. By the late 1920s, Weinberg was so successful that he was approached by Abe Saperstein with an offer for a percentage in the Harlem Globetrotters, which he turned down. Weinberg booked all the big bands and even had some acts, like Louis Jordan, under contract. Jordan was in Bluefield in 1942 when he had a run-in with W.W. "Squirrel" McNeal, which prompted him to write, "Salt Pork, West Virginia." Shown here at the Matz Hotel, from left to right, are State Trooper ? Williford, unidentified, Jack Dempsey, Dick Powell, Stubby Currence, and Ralph Weinberg. (Photo courtesy of author.)

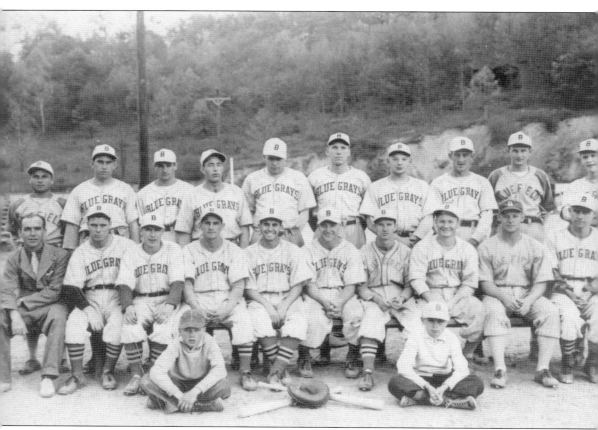

PLAY BALL! The Bluefield Blue Grays were the city's entry into Class D baseball through the Coalfield League. While there had been baseball in the coalfields through the years, an actual league bearing the name was only around from 1937 to 1941 and included the Beckley Bengals, the Huntington Booster Bees, the Logan Indians, the Williamson Colts, the Blue Grays, and the Welch Miners. The league was founded by Ray Ryan, and its most famous player was Stan "The Man" Musial, who joined the Williamson Colts in 1938. (Photo courtesy of Grubb Photo Service.)

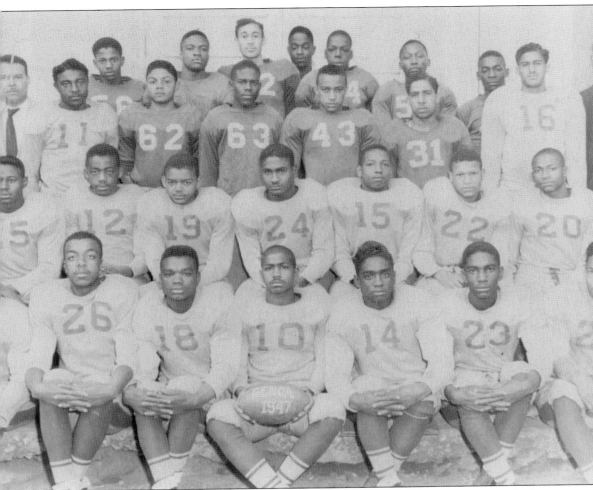

FOOTBALL. The Genoa High School football, basketball, and track teams were among the best in the nation at various times throughout the school's history. Genoa was located off Wilson Street in the city's mid-town section and served the African-American community until Park Central High School was built on the northside. The Park Central "Thundering Herd" continued the tradition of excellence established at Genoa until it was closed in 1969 following integration. (Photo courtesy of Joseph Bundy.)

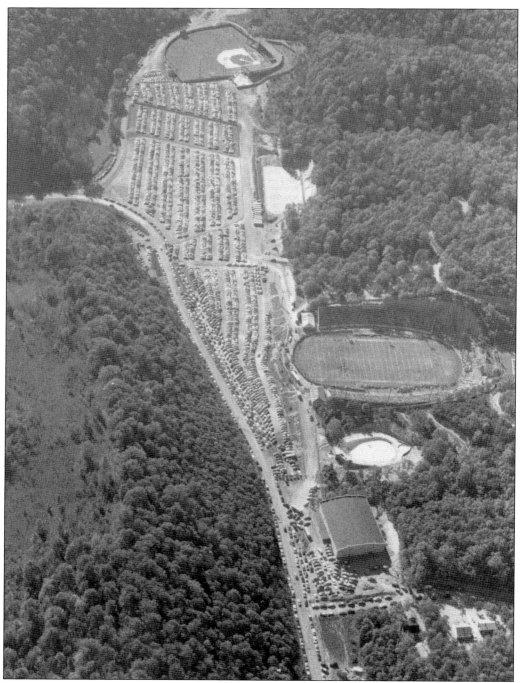

CITY SPORTS COMPLEX. The expansive city park complex, including (starting at the top) Bowen Field, the tennis courts, Mitchell Stadium, the old municipal swimming pool, and the city auditorium, has entertained huge crowds like the one that turned out for this 1950s-era "Coal Bowl" photograph. Mitchell Stadium was named for the city manager who was in office at the time of its construction. (Photo by Melvin Grubb.)

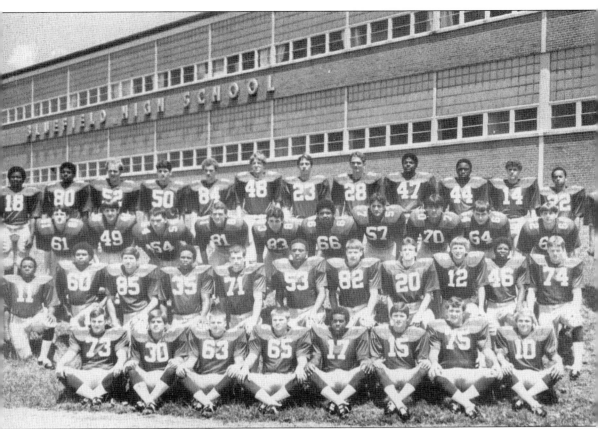

BEAVER. Few high school football teams have experienced the level of success the Bluefield High School team has seen. Under Coach Merrill Gainer, Beaver won state championships in 1959, 1965, and 1967, on their way to amassing an incredible 87-6-1 record from 1959 to 1967. Coach John Chmara continued the tradition by winning championships in 1975 and 1984, and Fred Simon closed out the string with a championship in 1997. (Photo courtesy of Nick Buzzo.)

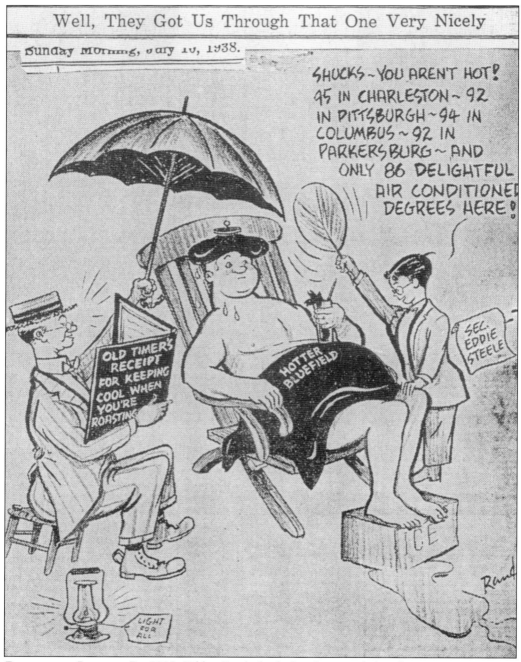

BEFORE THE LEMONS. By 1938, Eddie Steele had already coined the slogan, "Nature's Air-Conditioned City" to take advantage of the tourism potential of cooler summer temperatures. During hot spells, Rand Taylor would use his artistic talents to promote the chamber of commerce and the city. Eddie Steele was a frequent subject of Taylor's editorial sketches. (Drawing courtesy of H. Edward "Eddie" Steele.)

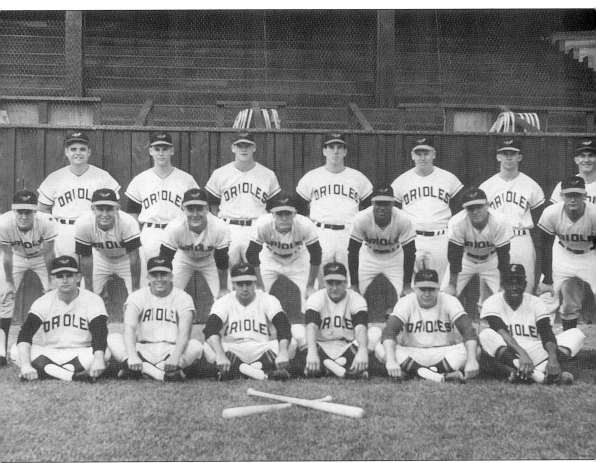

BIRDS OF SUMMER. Bluefield became affiliated with the Baltimore Orioles more than 35 years ago, and since that time, the city and the parent organization have enjoyed the longest-running continuous relationship between a major league team and its farm club. Baseball's greatest iron man, Cal Ripken Jr., played his first professional baseball game on the diamond at Bowen Field (shown here), and others like the great Boog Powell took their first professional swings in Bluefield. Joe Altobelli is shown here (standing on the far right) when he was manager of the Baby Birds. Altobelli went on to manage the Orioles in the Major League and skippered Baltimore to a five-game World Series win over the Philadelphia Phillies in 1983. (Photo courtesy of Nick Buzzo.)

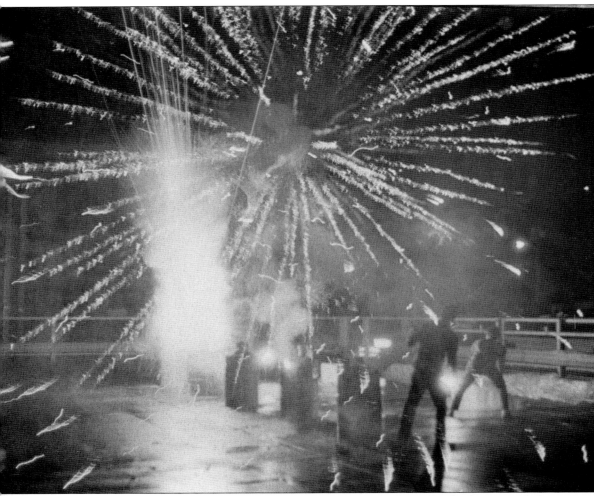

FIRE IN THE HOLE. The Craft Family Shooters fireworks family shot off a display in 1985 that became the subject of Melvin Grubb's dramatic night scene of the city, the railroad yard, and the fireworks together. While Mr. Grubb was on the Hardy Street Bridge creating a beautiful work of art, the author was on the top level of the Princeton Avenue Parking Building getting a close-up view of the process. This premature burst caught the shooters off guard, but caused no harm. (Photo by the author.)

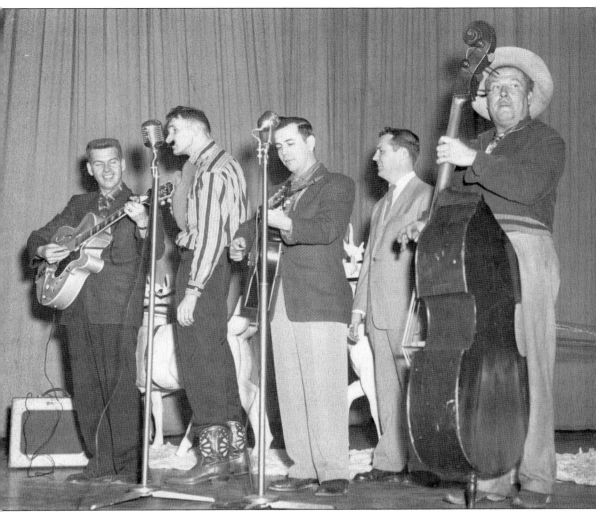

FOR THE KIDS. Since the early years of the 20th century, the *Bluefield Daily Telegraph* has hosted an annual community Christmas tree fund drive to ensure that needy children do not go without a Christmas. For 83 years, the community has responded to the fund drive. Distribution takes place a day or two before Christmas, and as the children arrive, they are treated to a concert by performers who donate their time to the show's success. Shown, from left to right, are the following: Smitty Smith, Ray Brooks, Cecil Surratt, O.C. Young, and Buddy Williams. (Photo courtesy of Cecil Surratt.)

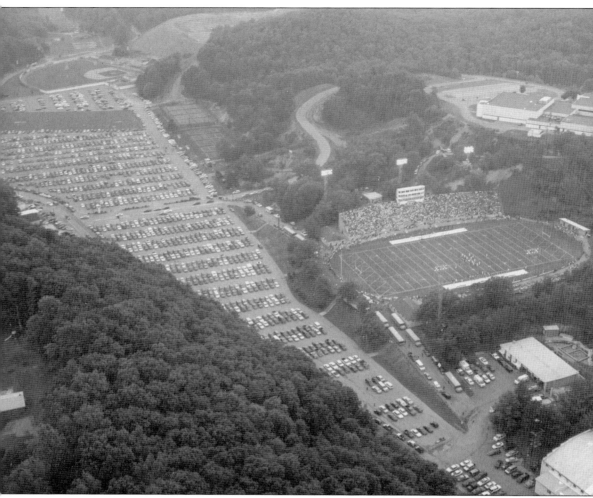

FRIDAY NIGHT FOOTBALL. The big game comes at the start of the season for the Graham G-Men from Bluefield, Virginia, and the Bluefield Beavers. Both football teams have experienced great success, and even in state championship years, the Beaver-Graham game carries a special meaning. (Photo by Melvin Grubb.)

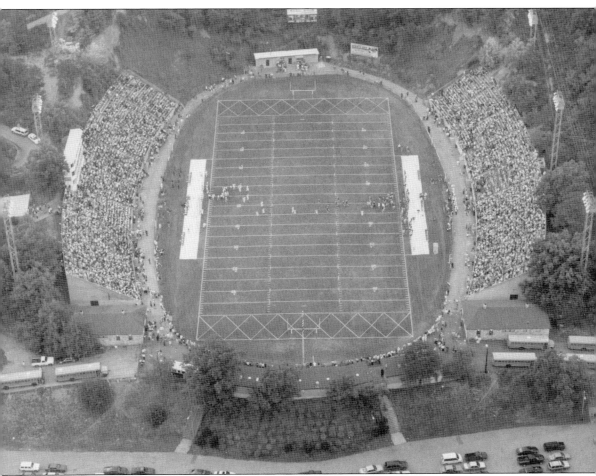

GAME OF THE YEAR. In the 1950s, the Beaver-Graham game would routinely draw in excess of 10,000 fans to Mitchell Stadium. Although those numbers have declined through the years as the region's population has dropped, there is still great support for high school athletics. (Photo by Melvin Grubb.)

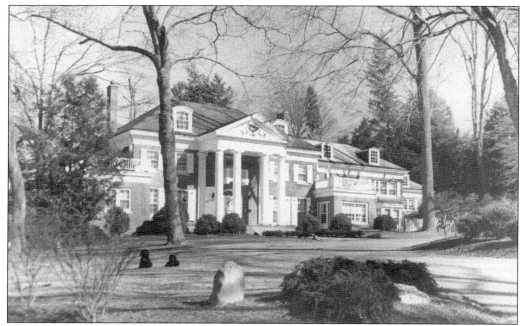

SOUTHERN EXPOSURE. The mansion shown here was remodeled and expanded by prominent Bluefield opthamalogist Dr. J. Elliott Blaydes Jr. The home was designed by Alex Mahood. (Photo by Evonda Archer.)

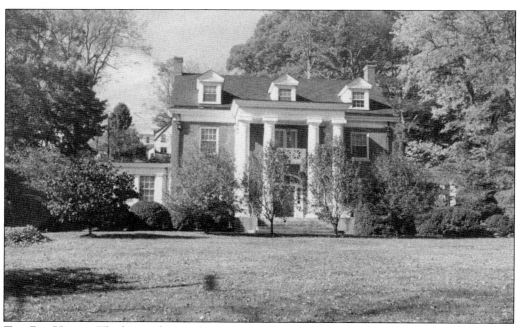

THE BIG HOUSE. The home shown above was recently remodeled by Dr. Randy and Kim Lester. It, too, was an Alex Mahood–designed home. (Photo by the author.)

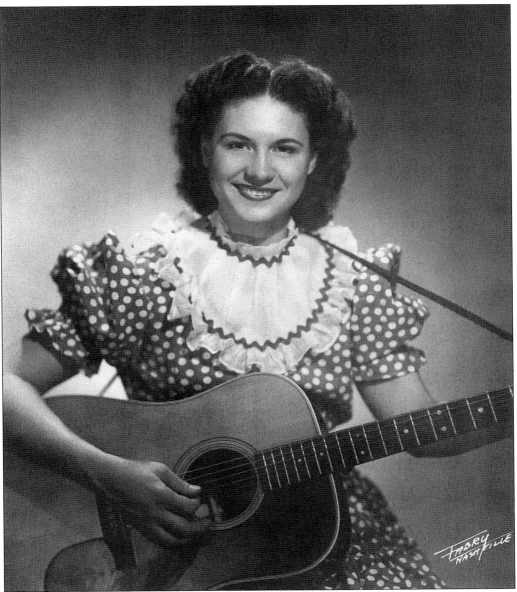

BIRTHPLACE OF STARS. Kitty Wells, one of the most popular female country vocalists of all time, was one of many artists who broke into the music business in Bluefield. Cecil Surratt recalls that Ms. Wells and her husband, Johnny Wright, of the *Johnny and Jack Show*, played local dance halls from 1939 to 1941, before they made it big in Nashville. Among others, Tom T. Hall put in time operating cameras at WHIS-TV before going on to become a big-time star. (Photo courtesy of Cecil Surratt.)

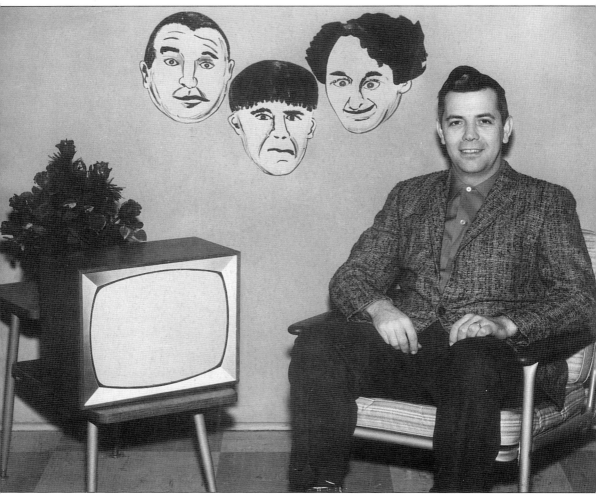

KIDDIE SHOW. Cecil Surratt was the star of his own kiddie show in the early days of WHIS-TV. The show featured reruns of the Three Stooges movies, and during commercial breaks, "Uncle Ces" would read letters sent to the studio by young viewers. After the first year, Surratt said the Stooges got pretty old. (Photo courtesy of Cecil Surratt.)

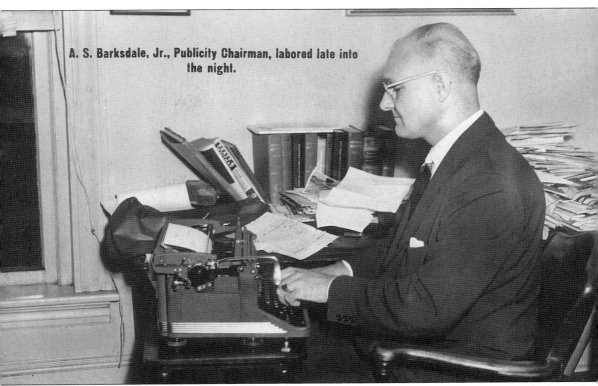

A. S. Barksdale, Jr., Publicity Chairman, labored late into the night.

THE WRITE STUFF. A.S. "Sid" Barksdale Jr. was one of the most talented writers who worked for the *Bluefield Daily Telegraph*. In addition to his workload as a news reporter, Barksdale found time to lend his talented fingers to good causes and even wrote a book, *Wheels on the Mountains*, the story of Jack Craft's bus empire. Barksdale later became a speech writer for U.S. Senator Robert C. Byrd. (Photo courtesy of H. Edward "Eddie" Steele.)

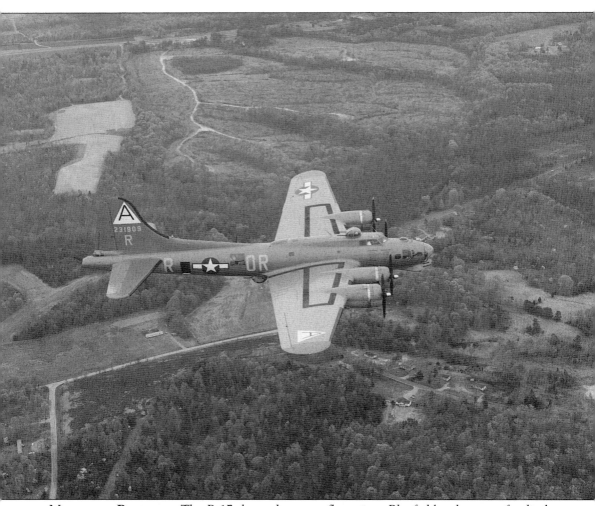

MISSION TO BLUEFIELD. The B-17 shown here was flown into Bluefield to be part of a display at the Mercer County Airport. The community's first airstrip was in what is now the Mitchell Stadium parking lot, but flying into and out of the valley was challenging for pilots. The Mercer County Airport is built on a mountain top just outside of the city. (Photo by Mel Grubb.)

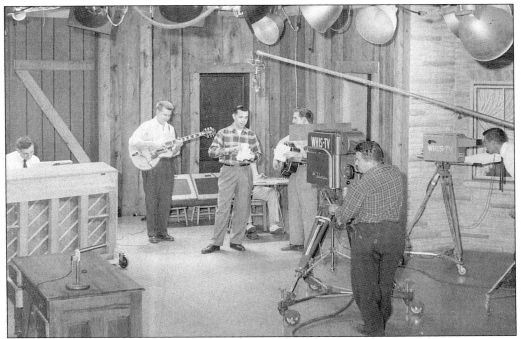

ROLL 'EM. Steve Walkavitch is shown here focusing his camera on, from left to right, Darnell Miller, Smitty Smith, and Cecil Surratt in the old WHIS-TV studio located on the third floor of what is now the Bluefield Arts and Science Center. (Photo courtesy of Cecil Surratt.)

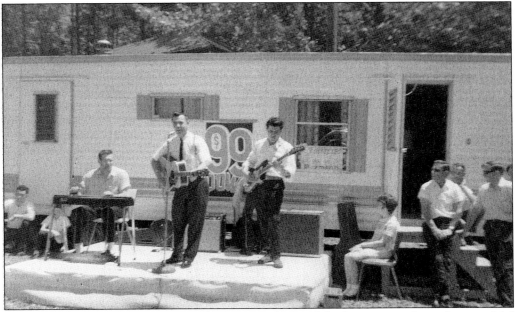

HOT LICKS. Buddy Pennington, Cecil Surratt, and one of the biggest stars from the area, Mel Street, are pictured performing at a mobile home show in 1966. Mel Street hit the big time with a number one hit. (Photo courtesy of Cecil Surratt.)

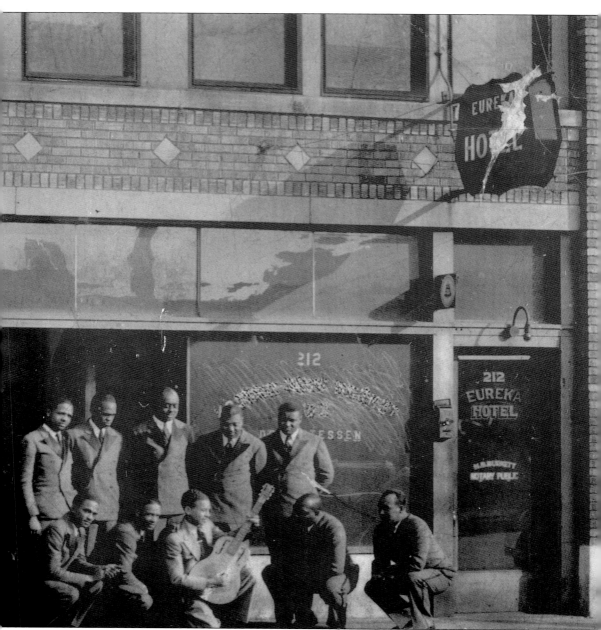

THEY CAME TO PLAY. Edward's Collegians from Bluefield, shown in this 1928 photograph taken in Memphis, Tennessee, toured the South, and at one time performed with the popular Stephin Fetchit Review. The band was led by Edward Watkins and stayed together until the early 1930s, when various members started dropping out to follow other interests. Other Bluefielders to make it big included Jacob and Zeke Carey of Davidson Street, who were original members of the Flamingos, a Chicago band that recorded the popular song, "I Only Have Eyes for You." (Photo courtesy of author.)

WITH A BANJO ON MY KNEE. Henry Jones of Bluefield is shown here picking out a tune on the banjo. From country to classics and jazz to jump, Bluefield had one of the most diverse musical influences of any community. In one week in the early 1930s, Roy Acuff performed live on WHIS radio to drum up record sales, and a few weeks later, Fats Waller played a brief set on WHIS to draw a crowd to the Granada Theater for a concert he had scheduled there. (Photo courtesy of Thurman Scruggs.)

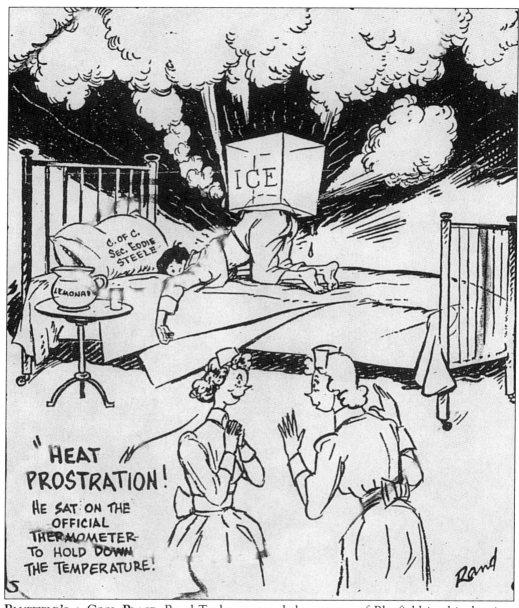

BLUEFIELD'S A COOL PLACE. Rand Taylor captured the essence of Bluefield in this drawing. Eddie Steele worked every possible angle on the city's mild summer temperatures promotion. He asked the local ministerial association to decry the "exploitation" of girls wearing shorts to distribute lemonade, then organized the girls to strike during a hot spell one summer. But that's Bluefield—one cool place. (Sketch courtesy of H. Edward "Eddie" Steele.)